PLUG-INS
for ADOBE® PHOTOSHOP®

A Guide for Photographers

JACK & SUE DRAFAHL

AMHERST MEDIA, INC. ■ BUFFALO, NY

This book would not have been possible without help from an overwhelming number of plug-in manufacturers. Their quick response to our request for trial software was invaluable. Our special thanks goes to Harald Heim from The Plugin Site. Although we have never met or spoken with him, he generously shared his vast knowledge of plug-ins and made our job much easier.

Published by:
Amherst Media, Inc.
P.O. Box 586
Buffalo, N.Y. 14226
Fax: 716-874-4508
www.AmherstMedia.com

Publisher: Craig Alesse
Senior Editor/Production Manager: Michelle Perkins
Assistant Editor: Barbara A. Lynch-Johnt

ISBN: 1-58428-129-4
Library of Congress Control Number: 2003112485

Printed in Korea.
10 9 8 7 6 5 4 3 2 1

CONTENTS

ABOUT THE AUTHORS

Jack and Sue Drafahl are a husband and wife team of professional photojournalists, lecturers, and multimedia producers. Their articles have appeared in *Petersen's Photographic, Rangefinder, Focus on Imaging, Outdoor Photographer, Sport Diver, Skin Diver, Dive Training, Diver, National Geographic World, National Wildlife Federation,* and *Cousteau* magazines. They have been actively involved in the digital transition since the early 1980s and are software and hardware Beta testers for companies like Adobe, Applied Science Fiction, Corel, and Ulead Systems.

Jack and Sue started their professional photographic careers at Brooks Institute of Photography, Santa Barbara, California. Jack later became an Instructor at Brooks and developed the Audio–Visual Department while Sue formed a commercial photography company.

In 1980, the Drafahls moved to Portland, Oregon, where Jack worked as an open heart surgery medical photographer. Sue expanded their commercial photography business, Image Concepts, to include clients like Intel, Fujitsu, and NEC. In the late 1990s they closed the doors of their commercial photography business to work full time lecturing, writing magazine articles, and eventually authoring photography books. They both received their diving certification in the early 1970s and are actively involved in the scuba diving community. Jack and Sue were awarded Divers of the Year from Beneath the Sea in 1996, and Sue is an inaugural member of the Women Divers Hall of Fame.

Jack and Sue make their home on the Oregon coast and enjoy teaching seminars worldwide on all aspects of photography, both topside and underwater. In addition to their various monthly articles, Jack and Sue have written four books: *Digital Imaging for the Underwater Photographer, Photo Salvage with Adobe® Photoshop®, Step-By-Step Digital Photography,* and *Advanced Digital Camera Techniques,* all from Amherst Media.

For more information on Jack and Sue Drafahl, please visit their web site at www.jackandsuedrafahl.com.

INTRODUCTION TO PLUG-INS

The world of photography has come a long way over the past 175 or so years. During that time, advancements in cameras, lenses, flashes, and film dominated the promotion. Now, all that has changed with the addition of two words—digital imaging. The mere mention of digital photography conjures visions of technology beyond the scope of most photographers, but in reality, the digital process is simple. It is just a matter of 1, 2, 3—input, edit, and output. The input process involves bringing in a digital file from a digital camera or scanned film. The middle process involves the computer and its operating system, hardware devices, and software. The output process enables you to see your printed file from a variety of printing devices such as inkjet, laser printer, dye sublimation, or film recorders.

There are endless types of software available today, but this book is about one specific type of software program called a plug-in. The problem with writing a book about using any type of software program is that nothing in the digital world stands still for long. New software versions appear about every two years, and upgrade versions are now common in photography. Fortunately for you, plug-ins are unique in that they are generally not upgraded, the manufacturers just offer new plug-ins with new features. This means that plug-in programs that you bought years ago can remain installed on your computer, along with the newer versions. This also helps keep this book current as the plug-in programs we discuss are still around, but more than likely there are new ones being added faster than you can finish reading this paragraph.

The world of plug-in filters is vast, yet virtually unknown by most photographers delving into the digital darkroom. To create this book we collected more than 5,000 plug-ins from a wide range of manufacturers. This created a unique problem as this was far more plug-ins than the software companies ever dreamed someone might have on one computer. We even tried installing half of them on two different computers, but there were still too many to manage. We found that Photoshop started to crash when we installed close to 1,000. Our only solution was to install five separate versions of Photoshop 7 and CS on several computers so that we could accommodate and test all the filters. Keep in mind that the 5,000+ plug-ins that we collected are only scratching the surface. We found single groups of filters numbering more than a thousand and many more just waiting to be discovered.

The process of creating a plug-in filter could easily fill a textbook alone. Though there are a few plug-in junkies who might be interested in that part of the process, we found that most photo editors just want to learn how to access and use these digital wonders. Our goal in writing this book is to show you what a plug-in filter is, where to find them, and how to best use them on your own photographic images. Dozens are being added to the marketplace every week, so the last chapter will be dedicated to what's available now and how to find resources on the Web for announcements of new filters.

Plug-in filters are some of the most powerful digital tools available for you to use in your digital darkroom. They can provide you more creative and technical control over your images than you ever dreamed. We love plug-in filters and use them extensively. Once you read this book, we think you'll be hooked on plug-ins too.

2

PLUG-IN BASICS

WHAT IS A PLUG-IN?

Basically, a plug-in is a small accessory program that is attached to a host photo-editing program like Adobe Photoshop. The advantage to a plug-in is that it loads in and out of memory as needed and can easily be upgraded or removed without affecting the main program. Plug-ins can perform a variety of special tasks within Photoshop—from image correction to creative effects and most anything in between.

The popularity of plug-in filters began with the introduction of Adobe Photoshop 2.5. Since that time, Photoshop has become the standard image-editing program in the indus-

try, introducing new versions about every two years. Adobe quickly realized that it could expand its creative potential by allowing software support from third party vendors. Before long, Adobe created a special plug-in interface so third party vendors could build their own plug-ins that would work inside Adobe Photoshop.

The initial plug-in filter versions were used to mimic the traditional photographic filters that most photographers carried around in their camera bag. These traditional filters created starbursts, repeated images, soft focus, graduated colors, and several other lighting and focus effects. The plug-in filter created the same

effects, except that it could be applied to any photographic image, long after its creation. You would simply load the digitized image into Photoshop and apply the chosen filter effect.

Photoshop does have its own plug-ins, which are installed during the initial Photoshop installation. The basic plug-in filters are found under the Filter pull-down menu in Photoshop and include more than a dozen groups of basic filters such as sharpen, blur, distort, noise, extract, liquify, pattern generator, and several other creative groups. Most of these filters are fairly basic, with the more advanced filters listed at the top of the menu.

In almost all cases there are third party counterparts that exceed or equal the capabilities of these filters. That's not to say that the standard Photoshop plug-in filters are not worthwhile, but rather that they are improving with each new version of Photoshop. It's just that Adobe has concentrated its efforts on producing a dynamite editing program rather than delving into any specific plug-in subject. This allows a symbiotic relationship between Adobe and third party companies that inevitably equips the end user with some very powerful editing tools.

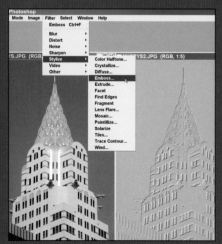 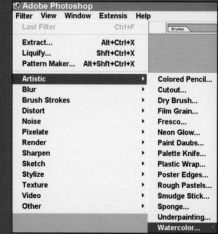

Left—This is an internal Photoshop plug-in. This filter is accessed from the Filter>Stylize> Emboss menu. When the filter opens, it is automatically applied to the entire image, and the effect is accurately reflected in the thumbnail preview image. The depth of the emboss is controlled using the rotating angle dial and a height and amount slider. **Right**—Internal Photoshop plug-ins are accessed from the Filter pull-down menu. The filters listed above the line are jump programs, which are discussed in chapter 3. Those listed below the line are standard Photoshop plug-in filters.

⬤ PLUG-IN INSTALLATION

Plug-in programs are installed after the main Adobe Photoshop program has been installed on your computer. In order for a plug-in to work properly and be recognized in Photoshop, it must be installed so that Photoshop can easily find and access the plug-in. During the plug-in installation, the program will ask or look for the location of Photoshop and install it in the appropriate plug-in directory. Most plug-in filters are installed in the root plug-in directory in Adobe Photoshop, or in directories for a specific group of filters made by a third party manufacturer.

Since you may have upgraded a time or two, there may be bits and pieces of the older Photoshop program on your computer. You might have even put the main Photoshop program on a second drive or not in the program directory. This serves to confuse things a bit, and as well written as the plug-in installations may be, they still might not be able to find the correct location for the current version of Photoshop. Not to worry though, as the program will generally stop and ask you to point to the desired install location. Just be sure to send it to the plug-in directory for the current Photoshop version you are using.

There are some plug-in programs that will indicate they have found the correct place for the plug-in directory and list it to show you where the directory is located. Be sure that you know where your version of Photoshop is located before you install any plug-in and verify that the informa-

Left—This is a typical install menu from Andromeda. Note that the program has stopped and has asked where it should install the plug-ins. **Above**—Plug-ins used for different functions in Photoshop each have a different file extension.

tion is correct before finalizing the plug-in installation. If you want to install the plug-in in a directory outside Photoshop, you will have to go to Edit>Preferences>Plug-in & Scratch Disk and add any additional locations of plug-ins outside the Photoshop plug-in directory.

When you move the location of Photoshop or Elements due to an upgrade or change in computer configuration, you need not worry. The basic plug-ins can be moved from the old plug-in directories into the new plug-in directory, and they will be recognized the next time you start up Photoshop.

The more complex commercial plug-ins may have to be re-installed into a new directory if you upgrade Photoshop or move it to a new location. Others will work well but require that you re-enter the registration number as some are sensitive to the initial install location.

⬤ MAC VS. PC

Before we venture too much further, we need to address the issue of operating system platforms—namely Mac vs. PC. We hear arguments all the time for one side or the other. We really don't care. As far as we are con-

cerned, a computer is a tool. Nothing more, nothing less. We based this book on PC, because the largest group of computer users are now on PC, and we found more plug-ins support on PC than Mac.

A Mac works just as well as a PC, and in many cases better, especially when it comes to graphics applications. If you are a Mac user and you want to try a plug-in shown in the book, you should check the manufacturer's Web site, which is listed at the end of this book, to see if it is supported. If it is not, don't despair as there is no doubt one offering a similar effect will be made by another manufacturer.

⬤ PLUG-IN EXTENSIONS

Each type of plug-in has a special file extension that starts with *.8 and adds additional letters depending on what type of plug-in operation is performed. The file extensions make it easy to locate types of files and copy new ones to a specific plug-in directory. For example, on the Windows platform *.8ba is used to import special file formats, *.8be is used to export images, *.8bf is used to create the

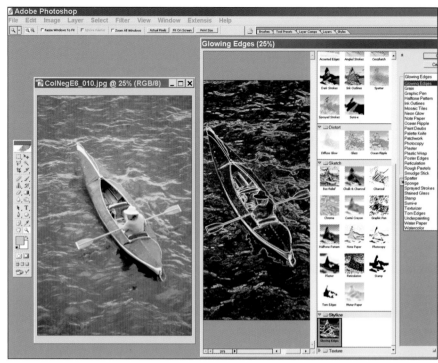

Above—Adobe Elements groups multiple plug-in filters together so you can easily create more advanced effects. These grouped filters are found under the Window>Effects menu. There are no control menus for the effects. You just drag the one you want onto your picture and it activates immediately. **Right**—The most recent version of Photoshop, CS, incorporates the same thumbnail plug-in gallery that was so popular in Elements. When you click on a certain effect, controls appear on the right, and an enlarged preview thumbnail is displayed on the left. As you change your selection from the gallery, each new choice is shown in the thumbnail preview image.

thousands of plug-in filters, *.8bs for image selection, and many more.

As you work your way through this book, you will see references to a plug-in or a plug-in filter. Most of the examples in this book are geared to the plug-in filter (*.8bf), since the bulk of plug-ins are either corrective or creative filter effects.

● WHAT PROGRAMS SUPPORT PLUG-IN FILTERS?

Adobe Photoshop. Adobe has worked very hard to dominate the photo-editing software field, and has done a good job of it. Yes, there are other manufacturers, but none have the following of Photoshop. Most all

the third party manufacturers of plug-ins make them solely to work with Photoshop or Photoshop-compatible software.

Adobe Elements. With the introduction of Adobe Elements, you now have many of the features of Photoshop, but at a much reduced cost. Elements installs a very large assortment of plug-in filters and will recognize most of the third party filters that can be installed in Photoshop. The advantage of Elements is that it has a plug-in manager that allows you to preview the plug-in effect with a standard thumbnail image. The Elements plug-ins are located under the Filters pull-down menu, which is located on the docking bar.

When you find the plug-in effect you like, you can drag it onto the image and it will be applied to your photo. The thumbnail preview is restricted to Photoshop plug-ins; you will not be able to preview third party plug-in effects.

A second pull-down menu on the docking bar is labeled Effects. These action programs combine the power of several filters into a new, more powerful filter effect. Oil pastel, Neon Lights, and Blizzard are just a few of the fifty plus filter groups installed with Elements. Both the Filters and Effects pull-down menus are grouped so that you can look at all the effects, or effects that are similar.

As we prepared this book for publication, Photoshop CS was introduced. It now features the same type of plug-in manager with thumbnail preview as found in Elements.

Adobe Photoshop–Compatible. Almost every photo-editing program on the market will have some kind of plug-in program that is either installed along with the main program or can be added later. Since Adobe Photoshop is the standard in the industry, the bulk of the third party plug-ins are Adobe Photoshop–compatible. This means that the filter will work in any

program with that designation. Programs like Corel Painter, Ulead Editor, Deneba Canvas, and Jasc Paint Shop Pro all have the capabilities of interfacing with most third party compatible plug-in filters.

Pointers and Links. If you are using multiple editing programs and all need to access the plug-in filters, then you must group the filters outside the program and have them individually point to that access location. Most programs, including those made by Adobe, have a preference section that allows you to access plug-in filters from locations outside the program.

Another way to access outside filters is to use a shortcut. In your outside directory of filters, right click on a specific filter and create a shortcut. The shortcut can then be moved into your editing program and listed in its filter menu. That way when you want to select that specific filter, the editing

Plug-in filters in Photoshop are accessed from the Filters pull-down menu at the top of the editing screen. The filters are organized in three groups. The group listed at the top are the internal jump programs. The middle group are the basic plug-ins that are initially installed with Photoshop. The group listed at the bottom are third-party plug-ins.

program will jump to the shortcut and take you directly to the outside listing.

● WHERE ARE PLUG-IN FILTERS LOCATED?

The bulk of plug-in filters are located under the Filter pull-down menu in Adobe Photoshop or Elements. Additional plug-ins are located in the File menu under Import, Automate, or Export functions in Photoshop. A few of the newer plug-in filters will be installed in their own pull-down menu at the top of the Photoshop menu bar. When you access filters from these pull-down menus, you will notice a small line separating the filters. Filters above the line are those installed with Photoshop. Those listed below the line are reserved for third party filters installed after the initial installation of Photoshop.

Many of the plug-in groups have submenus that break out into specific filter effects within that named group. For example, you might access the Filter pull-down menu and select the Alien Skin Image Doctor group. Once this menu is selected, it opens into Smart Fill, JPEG Repair, Scratch Remover, and Spot Lifter. Selecting any of these items will then open the appropriate menu.

● PLUG-IN FILTER COMPATIBILITY

Adobe Photoshop, Elements, and Photoshop-Compatible. The bulk of Photoshop-compatible filters will work in almost all versions of Photoshop, from version five up and Adobe Elements. Other Photoshop-compatible programs vary regarding which

plug-in filters work and don't work. If you plan to use a program other than Adobe Photoshop to use the plug-in filters and find that some of the filters are not recognized, you might consider picking up the lower priced program, Adobe Elements, to access those filters. That keeps the cost down, and between both programs, all the filters should work.

In a few rare cases, you will find that an older plug-in filter installed into Photoshop may lock up your system. If that happens, uninstall the filter and try it in another third party editing program that recognizes Photoshop-compatible filters. Or better yet, try it with an older version of Photoshop.

In our digital darkroom, we have a computer with Photoshop versions 2.5, 3, 4, 5, 5.5, 6, 7, and CS for testing the various plug-ins in this book. So far only a few have not worked on versions 7 and CS, and those that struggled worked well with versions 5 and 6. Since most users upgrade their software when a new version of Photoshop becomes available, you likely have an older version of the program hanging around. We experienced no compatibility problems with the above-mentioned versions of Photoshop installed on one Windows XP computer at the same time, so if you have multiple older versions installed, each will work fine. Be warned though that if you decide to uninstall one of the versions, it may disable features in some of the other programs. The solution is simple if that happens—just re-install the one you want to keep, and it will fill in the missing parts.

● LOST PLUG-INS

Over the years a few great plug-ins have come and gone. In almost all cases these filters disappeared because the parent company that developed the plug-ins was sold to another company. These plug-ins were then combined with others from the new company or discontinued. Case in point is the KPT series of plug-ins developed originally by MetaCreations. The bulk of these plug-ins were sold to the Corel Corporation and eventually combined into one KPT Collection, but not all the original plug-ins made the final cut. In our search for plug-ins for this book, we found more than a half dozen other cases where the same scenario created lost plug-ins.

Lost, But Not Forgotten. For those who want to find and experience those lost plug-ins there is hope. Our search uncovered several software wholesalers and retailers who still have many of the original lost plug-ins in stock. A quick search on the Web will usually tell you if this is the case. We even found a couple of lost plug-ins being offered free as a download, indicating that the plug-in had been discontinued by its original company and not resold.

We feel that some of these lost plug-ins still have great value and can be found with just a little searching on the Web. For that reason we have included a few of the lost plug-ins in the book and have included some in our Web resources in the last chapter of the book. If any of our sample images use a plug-in that is no longer readily available, it will be clearly noted.

AUTOMATIC

The basic plug-in filters in Photoshop will start to work as soon as you select that specific plug-in command. There will be no preview or control, it just goes to work processing and finally produces a new image. If you don't like the results, you can use the Undo function, or the Step Backwards function and try a new variation.

In Adobe Elements, the automatic function consists of selecting the effect you like and dropping it on the image. If you don't like the effect, Undo or Step Backwards, and you are ready to try again.

MANUAL ADJUSTMENT

Once you select a specific filter, the majority of the plug-in filters will present you with a small menu. Most have a small preview image and provide filter adjustments in the form of sliders, dials, or three-dimensional lighting toggles. Moving the slider, dial, or lighting toggle in a specific direction will provide an immediate visual change in the thumbnail. This makes it easy to see if you like the desired effect before taking the time for the full process to occur.

For those programs without a thumbnail preview, it will be harder to make an educated decision, as applying the desired effect will be a matter of trial and error. You will have to keep using the Undo function and trying another option until you have the desired effect.

Keep in mind that the more sophisticated the effect, the more controls you are offered with the filter. More complex settings can often be saved out and later reloaded with other images so you can apply the same effect.

PRESET

A new feature offered in many of the more recent plug-in filters is the preset function. When this type of plug-in filter is selected, a series of small preview thumbnails will display a generic image that shows all the effects of the filter. Simply select the preset you like, and it will be applied to your image.

In most cases, you can manually adjust a preset image with the sliders

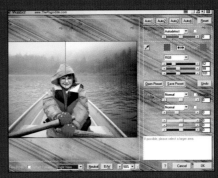

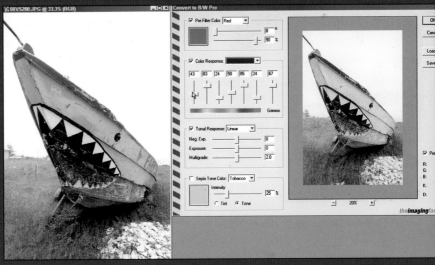

Top—This is the editing window in the Color Washer plug-in from The Plugin Site. This filter is used to achieve accurate color balance in your images. It uses auto detect, manual controls, and multiple comparison views to help you make your choice. Bottom—When you need to convert your images from color to colorless, the Black and White Pro from The Image Factory works well. It provides more control in this conversion process than is available with Photoshop. Various controls enable you to adjust the visible spectrum to achieve your desired effect. Advanced settings will allow you to match grayscale properties of certain films. You can even adjust this filter to simulate different multi-grade darkroom printing filters.

and dials and create your own preset, which can be saved out along with the installed presets. Some of the programs also allow you to select the display image you want to use for the preset. Others will display the last image you used with the effect and show how it worked with the image.

● JUMP PROGRAMS

Some plug-in filter programs are so complex that when activated, they open their own stand-alone program. Photoshop will be minimized at this time to conserve memory usage. You can then make all the adjustments you want to the image, and the program will jump back into Photoshop when the effect is completed.

These programs are quite memory intensive and usually require a minimum of 512 MB of RAM. Some good examples of jump programs are Auto FX, Deep Paint, and Corel KPT.

● DUAL OPERATION PROGRAMS

This type of plug-in program will install as a plug-in to be used with Photoshop and as a full stand-alone program that will operate independently of Photoshop. The advantage to this is that you have two very powerful programs at your fingertips. The disadvantage is that their dual power may cause your system to slow down when using the plug-in version. Just close Photoshop, reload the image in the stand-alone program, and you will have more memory at your disposal. Both AutoFX Dream Suite and Right Hemisphere's Deep Paint use the dual operation method for creative imaging.

Hardware plug-ins for most film scanner programs such as SilverFast and NikonScan also fit into this category. With these programs some of the more intensive functions, such as batch scanning, must be done outside Photoshop to work efficiently.

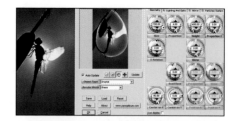

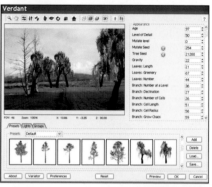

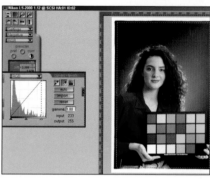

Top—The Panopticum Lens Pro filter menu demonstrates the use of rotating dials to control the filter's effect. The primary purpose of this filter is to create different shape lenses that float over your background image. The light diffracts through the lenses for special effects. Center—This menu, from Digital Elements' Verdant plug-in filter, demonstrates the use of presets that can be quickly applied to your image. The dice icon can be used to randomly select features in the presets to achieve variation. Bottom—Most scanners feature both stand-alone and plug-in programs. This allows you to modify the color balance, gamma, brightness, contrast, and sharpness as you scan your images.

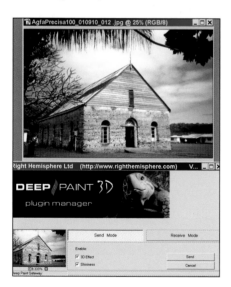

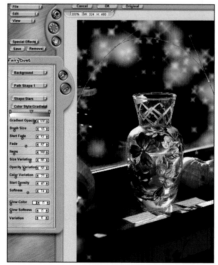

Left—Deep Paint 3D from Right Hemisphere is a sample of a jump program. This menu demonstrates how some jump programs give you the option of sending or receiving the photo. Right—Mystical Lighting from AutoFX is also a jump program that uses both sliders and presets. The presets make it easy for beginning editors to achieve great results, while the sliders provide more advanced editors the tools they need to experiment.

IMAGE CORRECTION

CORRECTION PLUG-INS

A correction plug-in filter is designed to correct flaws that appear in a photographic image due to problems with exposure, processing, handling, printing, lighting ratios, equipment malfunction, scanning errors, and more. These are just some of the problems

commonly encountered when dealing with film and print images. Digital cameras have their share of the same problems, plus a few more that are specific to digital. Digital camera noise, JPEG artifacts, white balance, and image sharpness can now be added to the list of imaging concerns. The list becomes even longer with the addition of such concerns as improper focus, camera movement, and poor framing.

The quantity of potential photographic errors that can occur from the initial image conception to a final product are enormous. Therefore,

many plug-in filter correction tools have been added to the image editing programs to help offset these errors. The three most significant problem areas are color balance, exposure, and gamma detail. We will start there and work our way down to some of the lesser problems.

COLOR BALANCE AND EXPOSURE

We have grouped color balance and exposure into one g0roup since most color correction plug-ins also make exposure corrections.

There are three basic methods for color and exposure correction in a photographic image—color sliders, visual selection, and eyedroppers. Adobe Photoshop uses all three with image adjustment commands, and they work fairly well for most of the basic color shifts.

When you encounter images demanding more complex corrections, you will want to consider one of the offerings from the third party plug-in companies. Their filters give you increased options for correcting the more difficult color and exposure shifts.

Using Control Sliders. The most popular method for color control is using control sliders. To shift the image color, you can select either red,

Top—Sometimes you will encounter images that are underexposed. This image comes from a scanned color negative. **Above**—Using iCorrect Pro from Pictographics, you can easily remedy the problem using a neutral eyedropper to color balance the image.

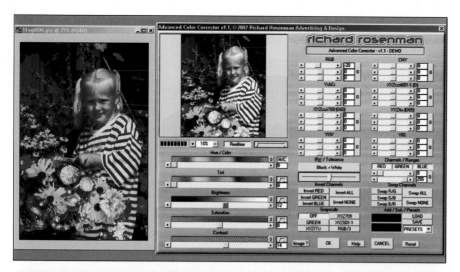

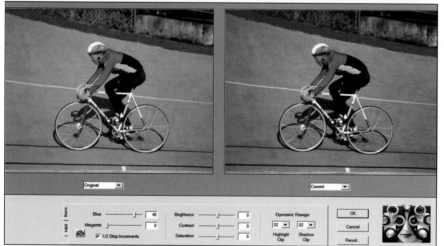

Top Left—Richard Rosenman's Advanced Color Corrector features almost every color correction possible. It makes use of sliders to adjust color balances in Grayscale mode, RGB, CMYK, and more. **Above**—If you enjoy using the Variations function in Photoshop to select your color balance, then you will love Test Strip from Vivid Details. It divides your image into strips with various color options that make it easy to make an educated color choice. If you prefer, it can also feature the ring-around method or side-by-side comparisons. **Bottom Left**—The new plug-in from PhotoTune Software, called 20/20 Color MD, takes a totally different approach to color correction. They provide two images side by side and ask you to make a choice. Then they present another two options for your selection. After ten times of this back and forth testing, the software zeros in on your perfect color balance choice.

green, or blue sliders for RGB, or cyan, magenta, or yellow for CMYK images. Each movement of a slider provides an immediate visual change in the image so you can make an accurate correction decision. Some of the programs feature a helpful before-and-after correction illustration.

Visual Selection. If you are new at image editing or have a particularly difficult color shift, you may want to select a color correction plug-in program that gives you a ring-around selection of images. With this type of program, you will be presented with an image version containing the present color shift, usually located in the center of the ring of images. Around this, a circular pattern of image varia-

tions containing more red, green, blue, cyan, magenta, and yellow will appear. Generally there will be an option for exposure correction as well.

These plug-ins operate much like the Variations command in Photoshop but generally feature many more options. In several of the programs, you are given viewing choices that break the image up into squares, each with a color variation. Others use the test strip view, which slices the image up into several panels, each with a slightly different color balance. One program we found worked like an eye test with side-by-side comparisons.

Eyedropper Method. Some of the plug-in programs take the eyedropper concept to new levels of image edit-

ing. In addition to the black, gray, and white eyedroppers, these programs can balance for neutral, sky, grass, and flesh tones. They even allow you to add custom colors to the eyedropper palette.

We find this type of program great for working with pictures of cameras shot on white backgrounds. The bodies are usually not white, black or gray, but silver or off black. Using a neutral eyedropper on the surface of one of these cameras will quickly balance the image without changing the image's exposure density.

Presets. Presets in plug-ins designed for color balancing make it easy to address both common and more challenging color balancing problems.

For example, a "Remove Red Shift" preset could be used to quickly correct photographs taken under tungsten light with daylight film. The same preset could also be used to correct a red shift caused by an incorrectly set white balance setting on a digital camera.

Faded Images. A special type of color balancing plug-in is designed to help images that have faded over time or have drastic color shifts. This type of plug-in will usually be referred to as a color restoration plug-in. It has the ability to analyze images at the color layer level to re-create the color found in the original image. We found this type of correction plug-in a great tool for off-color shifts encountered from images taken under fluorescent and halogen lights and even for some images taken underwater without strobe lighting.

GAMMA CORRECTION

Loss of shadow detail is a common problem with many images today. This can be caused by harsh lighting, lack of flash fill in sunlight, underexposure, or even from film scanning errors. Whatever the reason, these images generally have a good black and white, but most of the midrange detail is dark and hard to see.

In all Adobe Photoshop versions through 7, this problem is addressed by using either the Levels editor or Curves editor. Photoshop CS now includes a new type of shadow and highlight correction that uses sliders to increase the midtones' density. Even so, it still takes a skilled hand to accurately correct this problem.

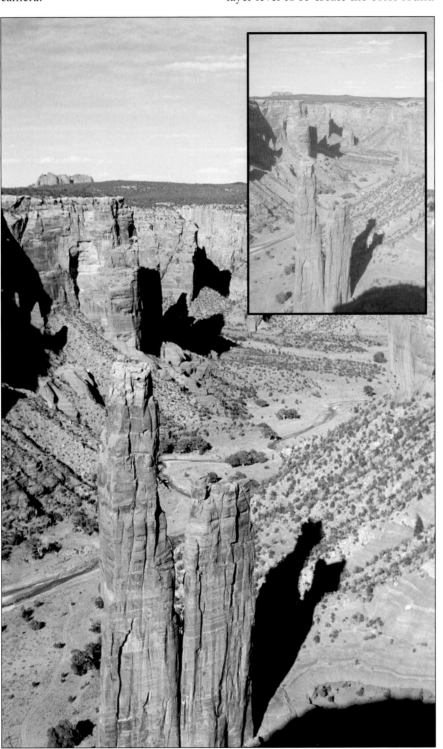

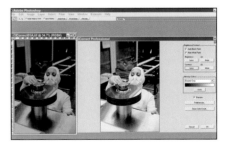

Left—Here we find an old, faded color slide and the results of applying Kodak's Digital ROC plug-in filter. Digital ROC automatically compensates for color differences generally caused by the effects of time. **Above**—We used iCorrect Pro from Pictographics to correct the fact that this image was photographed under fluorescent lighting. Using the neutral eyedropper, we touched the mask and lab coat to achieve a neutral tone. We then used the brightness and contrast control to finalize the image.

The solution is a type of plug-in that analyzes the midrange detail and automatically adjusts it without damaging the detail in the white and black areas. Most of these plug-ins have the ability to bias the Auto feature so you can make either minor or major gamma adjustments.

● GRAIN REDUCTION

As the ISO speed of film gets higher, so does the grain structure. When scanners first came out, grain reduction was accomplished by a hardware plug-in connected to the scanning process. However, since many images were scanned before this hardware technology came to be, a need for a non-hardware version became necessary. The hardware version is still the best, but if you don't have it, the software version is a good solution for grain reduction.

Grain reduction plug-ins use a combination of blurring and sharpening technology that can blur the grain yet still maintain the image detail. Control sliders are used to adjust the strength of the plug-in, and the diffusion method. A before-and-after visual representation makes it easy to understand how the sliders work so you can retain image detail and obtain the best grain reduction.

● DIGITAL CAMERA CORRECTIONS

As mentioned earlier, digital cameras have a unique set of imaging problems. Among these is a phenomenon called digital camera noise, which is similar to film grain. This noise increases as you increase the ISO speed on your digital camera—just like film grain—and generally can be corrected in the same manner.

Unfortunately, digital cameras feature many different chip configurations, which complicates the problem even more. In the last couple years many new plug-ins designed especially for digital cameras have surfaced. Most of these new, high-tech plug-ins require that you select your specific camera model and then the camera ISO setting before it adjusts the final image. In addition, many of these correction plug-ins can remove hot pixels, reduce JPEG artifacts, and correct color aberration problems.

As the digital camera becomes the dominant method for taking pictures in the next few years, we expect to see an explosion of plug-ins from camera manufacturers and third party companies that specifically address this problem. You'll find more on digital camera plug-ins in chapter 19 and in the

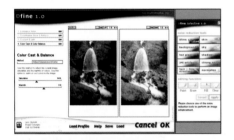

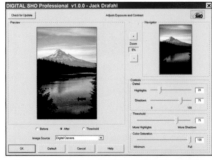

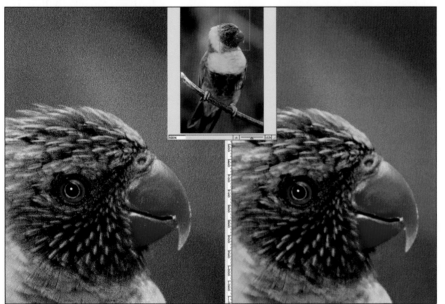

Top Left—Dfine, from nik multimedia, is a specialized plug-in filter for digital camera users. This plug-in will reduce luminance and chrominance noise and JPEG artifacts or adjust contrast and color. The palette on the right can be used with either a mouse or graphics tablet and is activated from the File>Automate>Dfine Selective menu. **Top Right**—Digital Sho Professional is available from Kodak's Austin Development Center. This powerful plug-in is used to recapture detail that has been lost in both the highlights and shadows. **Above**—Digital GEM, also from Kodak's Austin Development Center, is used to reduce the grain structure without impairing the overall sharpness of the image. The image on the left is a scanned high-speed color negative, and the image on the right shows the results of applying Digital GEM. Note that the center navigator image shows how small a portion of the image we are viewing.

 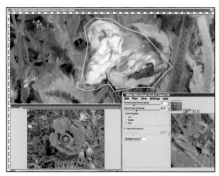

Top—This plug-in comes from the Image Doctor's bag of tricks from Alien Skin. Smart Fill allows you to select the distracting foliage around the edges of the photo. When you expand the problem area and then apply the Smart Fill plug-in, the unwanted flowers magically disappear.

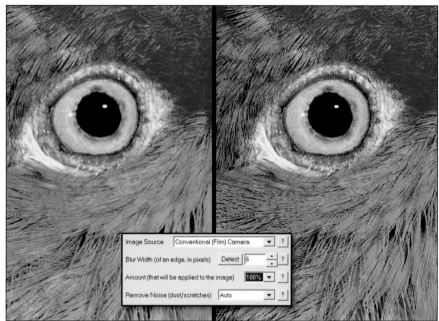

Focus Magic, from Acclaim Software, sharpens images that are blurred or out of focus using tools more advanced than Photoshop's Unsharp Mask. This plug-in works well with both film and digital images; it automatically detects problems and applies its own solutions. It even removes dust and scratches with ease. You also have the option of doing the adjustments manually.

digital camera links section in the appendix.

● SHARPEN AND SOFTEN

Sharpen and Soften are some of the most common features in photo editing programs. Some are located in the plug-in directory, while others are part of an image editing pull-down menu. In most cases, these controls apply directly to the image and offer you very little control over how they affect the image. Smart blurs and unsharp masks are part of this group, and these offer better control over the degree to which the effect is applied and which parts of the image are affected. Even with the advanced versions of these filters, you may sacrifice quality because you don't fully understand how the

filter works or because the filter just doesn't offer enough control over the problem.

Most of the third party soften filters come as part of a creative plug-in, while the sharpen filters are usually by themselves. Since unsharp mask filters are so hard for many image editors to understand, these third party versions try to simplify the application of the effects by asking questions during the process and automatically assigning a specific solution. How large is the image file? What will be the viewing distance? Which printer will you use

and what size print? Do you require maximum quality or just a quick draft output? Will you be viewing only from a computer screen or will there be a print output? Once these and other questions are answered, the plug-in filter will automatically sharpen the image to match those requirements. It is a good idea to save those images out as a new file name, since printers and viewing distances may change from time to time.

A new type of sharpen plug-in has just begun to surface that addresses problems due to camera operator

error. Who would have thought that it would be possible to correct for camera shake and poor focusing techniques? It makes you wonder if images you tossed away could have been saved with today's plug-in technology, doesn't it?

These filters are easily identified, as most will have the word "focus" included in the plug-in name. They generally have controls for automatic adjustment, or manual controls that feature before and after comparisons. Before any correction can be applied using this plug-in, the type of focus

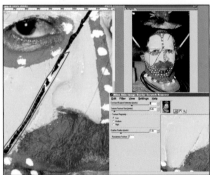

The Image Doctor, from Alien Skin, even includes a Scratch Remover. It works much like the Smart Fill, but allows you to fill lines that cross areas with varying hues and tones.

problem needs to be identified from a list of possible preset situations. The list can include digital camera, film camera, video camera, and TV signals, as well as the reversing of softening filters.

● DUST AND SCRATCHES

Some scanners on the market today have hardware plug-ins that automatically remove dust and scratches as the

images are being scanned. If your scanner does not feature this technology, your next option is the Dust & Scratches filter that comes as part of the plug-in set in Adobe Photoshop and Elements. This filter is great for those images with minimal damage, but offers very little help for images with more severe problems.

Dust. Since most dust resembles large particles of grain or digital noise,

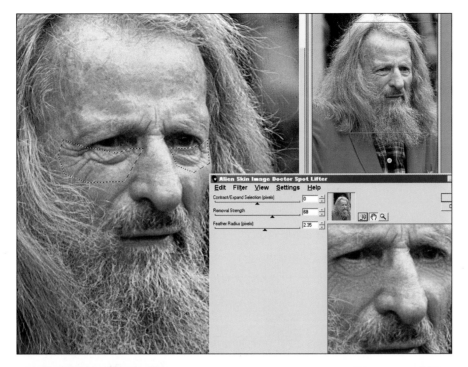

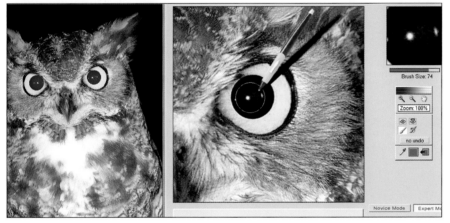

you might be able to reduce most of the smaller particles using a grain reduction or digital camera noise reduction plug-in. The larger dust particles are more difficult. Most image editors in the past have used the clone tool to re-move these larger particles.

Now we have a new breed of plug-in that takes the Clone tool to new levels. To remove a large dust particle, you merely select it with one of the many selection tools in Photoshop and apply the plug-in that is designed for removal of large objects in a scene. The plug-in will then fill in the selected area based on an analysis of the surrounding area so that the corrected segment blends into the surrounding area. The main control for this plug-in is the expand or contract slider, which is used to decide just how much of the surrounding area is used to fill the large object.

Scratches. Another version of this plug-in is used to remove selected scratches from film and print images. Care must be taken to select small portions of the scratch because it generally crosses different colors and densities. If you were to select too large an area, the tonal exchange would be very obvious. These plug-ins are not very common, but we expect manufacturers to release other versions soon.

● REMOVING FACIAL FLAWS

This plug-in works along the same line as a scratch plug-in. Images are first enlarged so that the facial flaws are visible. Areas around the flaws are selected, and then a facial plug-in filter is applied to the selection. Sliders and thumbnail previews of enlarged sections allow you to carefully tweak the corrections. This way the flaws are minimized, but it is not obvious to viewers that the image was edited. These plug-ins are rare, but we expect to see many more of these filters in the near future.

● RED-EYE REDUCTION

There is a red-eye reduction function in Elements, but not within Photoshop through version 7. In Photoshop CS, the Color Replacement function can be used to remove red-eye. Third party plug-ins are available for red-eye reduction and use brushes and clone tools to correct the problem.

We just received word at publication time that a new red-eye plug-in was in the final stages of development. This new plug-in will be unique as it is supposed to remove the red-eye problem without your having to select the eye. You just tell it to correct red-eye, and the plug-in goes in and selects the eye area and automatically applies the necessary correction. Sounds great, huh? We will hold off judgment until we have a chance to personally test it.

● LENS DISTORTION

Before the computer and the digital darkroom came into being, we had very little control over lens distortions. Barrel distortion, pincushioning, and vignetting are the three main problems that we have all experienced when using wide-angle and telephoto lenses. Thanks to the Photoshop-compatible plug-ins, we now have control over these issues.

Barrel Distortion and Pincushioning. Most of these plug-ins place a series of points on your image that

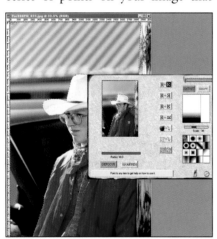

allows you to realign the straight lines. You will also find that many of these plug-ins have a list of known camera manufacturers, lenses, and presets. If you apply that information into the plug-in, the image will automatically be corrected based on the preset information.

Vignetting. To date, most of the control over lens vignetting problems is found in a plug-in that applies tonal gradation. By darkening and lighten-

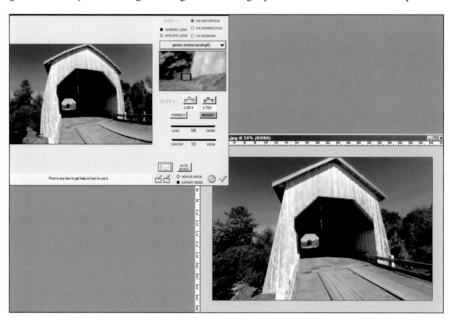

ing the image from edge to center, the vignetting problem is corrected. We expect to see future plug-in filters that will make this correction as part of a lens correction plug-in set or as a stand-alone plug-in correction for this problem.

● DEPTH OF FIELD

Photographers have always had the battle of getting everything in a photograph in focus. Limited depth of

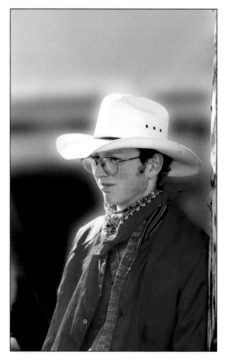

Above—Andromeda makes a series of plug-in filters designed to correct camera lens problems. Lens Doc corrects for pincushioning, barrel distortion, and lens vignetting. Corrections can be made manually or from presets that include both brand-name and generic lens choices. In this case, we are correcting a 16mm fisheye image. We placed three green dots on the left side and three yellow dots on the right side of the covered bridge. The filter aligned the dots into a straight line, and the final image resembles one taken with a wide-angle corrected lens (one corrected for barrel distortion). **Far Left**—Sometimes the area behind your subject is quite distracting. VariFocus, from Andromeda, is a specialized filter designed to defocus the background so your results resemble limited depth of field. **Left**—To use this filter, select the background using a tool like the Magic Wand, feather your choice slightly, and apply the filter for improved results.

field due to lack of adequate lighting, ISO ratings, and limiting aperture settings have always created a photographic challenge. It has also been difficult, especially in close-up photography, to make sure that the subject is in focus yet does not blend into the background.

Now there is hope with a type of plug-in that simulates depth of field in a photographic image. In effect, the plug-in filter creates a sharp point of focus in the image and gradually blurs the image as it moves away from that line of focus. This is a great plug-in filter for photography instructors who need to simulate depth of field with a single image.

If the subject in the scene dominates the image, you will probably have to select the subject first and then reverse select the background. You can then apply the depth of field plug-in to the selected background area. Care must be taken not to overuse this plug-in, as you may create an out-of-focus area that exceeds the optic ability of your selected lens.

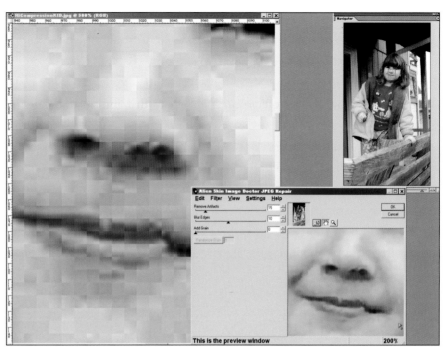

● CORRECTING JPEG COMPRESSION EFFECTS

The digital world has brought us a new problem. When film, print, or digital camera files are compressed or reduced in size to save disk space, a JPEG effect starts to appear called "jaggies." The jaggies or sawtooth edges of lines of compression in an image become more apparent as you enlarge the image.

Two solutions are possible. The first involves saving the file into a wave or fractal file format using a compres-sion plug-in. The new compressed file is then opened at a larger size that has the benefit of decreased jaggies. You can read more about this in our section on file import and export plug-ins in chapter 8.

A second, newer method of JPEG "jaggie" control is with a plug-in especially designed to correct this problem. You will find various controls with this plug-in to adjust artifact size, blurring of edges, and adding texture or grain. Again, ensure that the sliders are not set too high so you will not lose too much image detail in the process.

If the jaggies are more dominant in one area than another, you may want to use the Color Range or Magic Wand tools in Photoshop to select those areas. You can then feather your selection before applying the JPEG jaggies reduction plug-in.

● MASKING CONTROL

Masking plug-ins are used to select areas in an image so that you can

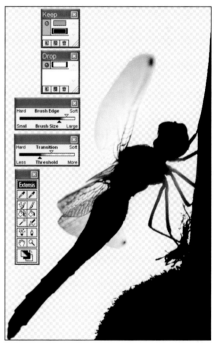

Top—When images are too small or compressed too much, your results may resemble the image on the left. By applying the JPEG Repair tool from Alien Skin, the JPEG artifacts are reduced while the image detail remains intact. **Above**—When you need to mask areas with extremely fine lines, the Extensis Mask Pro is a good choice. It allows you to gather the colors you want to keep and identifies those you want to drop. You can adjust the brush size and threshold to be very selective. If you find you need to made a selection correction, not to worry as it includes an eraser.

restrict the area where you apply another effect. Most of these masking plug-ins work very much like the Extract Masking tool in Photoshop, but provide expanded capabilities. Most use color eyedroppers to select or deselect specific areas as you try to separate them from the background. Once you have selected the colors you want to keep and the ones you want to drop, start to drag your magic mask-ing brush along the line you want to mask. The plug-in will automatically separate even very fine detail from the background. If your image has many colors in the background, you will want to create and save several sets of keep and drop eyedropper colors. This way, you can be sure that your mask-ing does not go into unwanted areas.

Practice Makes Perfect. The oper-ation of masking plug-ins is very com-plex and difficult to use for beginners. The key is to practice with sample images until you get the hang of how they work. Try not to mask too much of an area at once, and the process will be much easier. Start with images that have drastic differences of color be-tween the objects that you want to separate. From there you can hone your plug-in masking skills on more difficult images. Once you do, you will find that you can mask areas in a fraction of the time it would take you to manually complete the same task.

● PERSPECTIVE CONTROL

Perspective problems can be caused by taking pictures of rectangular objects at angles other than straight on. The problem often occurs when you pho-tograph a tall building at an upward angle. All the lines of the building nar-row at the top, providing perspective but not an accurate representation.

There are two plug-in solutions to this problem. The first can be found in some of the lens-correction plug-ins. With these plug-ins, when you select perspective distortion, you will be given dots that you manually assign to the vertical lines of the building. When you hit Apply, a new image appears where the sides of the build-

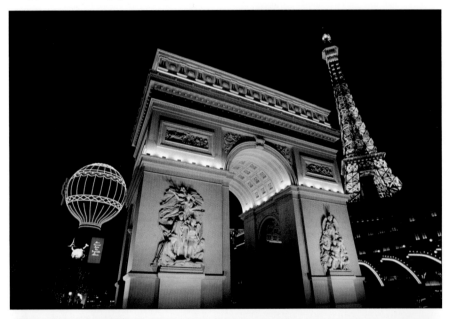

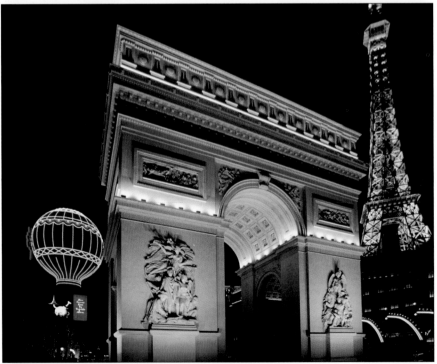

Top—When you photograph a tall building while looking up from the base, the building tapers from wide to narrow, providing per-spective. In order to provide an accurate rep-resentation of the building showing parallel lines, you must use a perspective control lens or the Lens Doc Perspective plug-in filter from Andromeda. Bottom—To use this filter, you assign dots to the upper and lower points on the building. When the filter is applied, it forces the dots to form a straight line. The program automatically crops the image to fill the frame.

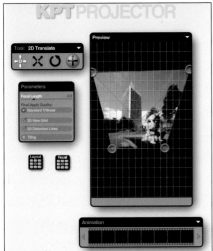

ing are parallel. If you have excessive distortion to correct, it may take several attempts to finally correct the image. These plug-ins provide a final cropped image with straight, parallel sides to the building.

The second solution is a perspective plug-in that works with all types of perspective distortion, no matter what the cause. This plug-in overlays a grid and provides you even more perspective control. You are given handles on the image itself that you manipulate into position over the grid. When you are pleased with the final correction, you will have to manually crop the final image.

The perspective plug-in can also be used to create perspective to form

Top Left—Corel Corporation offers KPT Projector to provide another solution to this perspective problem. **Bottom Left and Above**—With KPT Projector, a grid is first placed over your image. The four corners of the image can then be moved to align the building with the grid. After the plug-in has been applied, the sides of the building are straight, but you will need to crop your image to fill the screen. This plug-in can also be used to create animation for special effects. You can rotate on the x, y, and z axes to create a three-dimensional effect.

some very unusual creative effects. Image editors working to create three-dimensional effects may find this plug-in filter useful from time to time.

5
PHOTOGRAPHIC EFFECTS

● TRADITIONAL
SPECIAL EFFECTS

Before the computer became a viable photographic tool, special effects were accomplished with unique lenses, elaborate lighting, filters, cardboard cutouts, mirrors, or developing and printing manipulation in the darkroom. Effects created in the studio or darkroom required considerable time and expertise to execute flawlessly, so only a few bold photographers ventured into these areas.

● COMPUTERIZED
SPECIAL EFFECTS

Then a couple of things started changing the entire special effects process. All the movies and films we view were slowly being computerized. Special effects started taking a whole new, sophisticated direction. No longer were models and elaborate backgrounds being used as the computer could now improvise. The computerization quickly spread to the printed word, and we started seeing bizarre effects in all the magazine advertisements. Everywhere you looked, you could see the evidence and effect of the computer in our world.

Now the computer has become a standard photographic tool, giving the photographer the power to unleash powerful new imaging possibilities. With today's technology, if you can imagine something that you want to do with a photo, there is a program somewhere that will help you make it happen.

Most of these exciting new creative tools come in the form of plug-in filters, and they number in the thousands. In this chapter we will concentrate on those that mimic their counterparts in the traditional film world. In the chapters to follow, we will venture into those effects not possible before the computer entered the arena.

● SELECTING IMAGES
FOR CREATIVE EFFECTS

For creative plug-in filters to work effectively, you first must select a photographic image that will work well with the effects. Not every image will look good posterized, solarized, or burned at the edges. It takes some time to get a feel for what type of image works best with the different effects, so don't be discouraged. Keep in mind that if you don't like an effect created by a plug-in filter, it may not be the plug-in, but rather your image choice.

Many of the special effects plug-in filters take considerable time to render. We strongly advise that you pick a low resolution sample image to use when experimenting with new plug-in effects. Try to use the same image and save your own samples into your sample directory. Be sure to name the files by manufacturer and plug-in name so you can easily find the plug-in later. You will be surprised how many plug-ins you will collect once you get hooked on their use.

We found the best image for experimentation is the "Shed in a Field" that comes installed with the current version of the Windows operating system. The file is small and has the right components for comparing creative plug-in samples.

As we work our way through the remaining creative effects in this book, we will try to make suggestions as to what types of images work best with specific effects. Otherwise it will just be a matter of trying different images until you have a combination that works.

Many of the software plug-in companies have Web pages with galleries displaying images that show just what can be done with their filters. Most of these galleries will display a before and after image, so that you can easily see the full effect of their plug-in filter. In this book, we've even made it easy for you to locate these galleries, as Web connections are discussed in the final chapter.

● BICOLOR FILTERS

Often, traditional film photographers who used glass filters eventually ended up experimenting with a fairly expensive bicolor filter. The filter featured two opposite colors that, when rotated to match the horizon, added that color balance bias in the upper and lower half of the image.

The plug-in equivalent is considerably cheaper, more versatile, and features many more options. Plug-ins come both preset with specific colors and in a custom version that allows you to pick each color. Control sliders

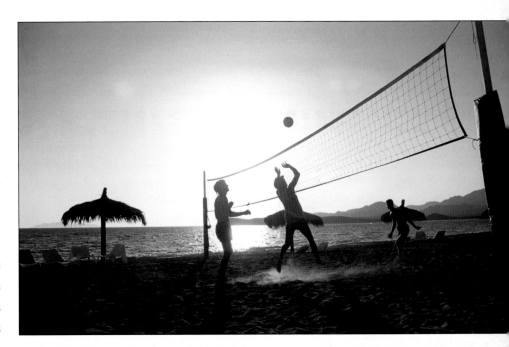

The Bicolor plug-in filter from nik multimedia features the option of preset colors or user-defined colors to enhance your photo. If the two colors you desire are listed in the preset options, then you are set. Otherwise, you have the option of selecting your own two colors, which gives you much more versatility. When you select this filter, you can control the vertical shift, rotation, overlap, opacity, and more.

allow you to adjust the center point between the colors, the overlap distance, and the opacity of the colors as they blend with the original background colors. You can even rotate the dividing line between the colors to match sloping hills or correspond with diagonal lines. This type of plug-in is best used with images that have washed-out or off-color skies.

◉ DIFFRACTION

In the traditional world of photography, a diffraction grating filter had thousands of precisely spaced ridges on its surface that acted like prisms. Bright point light sources photographed through this filter diffract the light into its spectral colors, producing rainbow colored starlights in the highlights. There were variations of this filter, and the filter you used determined the number of light spikes in the scene.

The software plug-in makes light diffraction easy, and it doesn't even need a light source to make the filter work, as it can magically add one. Sliders can be adjusted to provide control over the number of spikes, rotation of the spikes, and spike intensity. The best type of image to use with this effect is one that already has a point light source in it. The diffraction effect should be placed directly over the light source so that the shadows and highlights in a given scene look natural.

◉ GRADUATED COLORS

This plug-in replaces a group of photo filters that have a clear area and gradually change density or color from edge to edge. When placed over a camera lens, a white sky can become blue, orange, red, brown, or any other color, while the foreground remains unaffected. A neutral graduated filter is a popular choice to correct an extreme unbalance in scene brightness and density.

The plug-in version allows you to pick from thousands of colors, adjust the density of the color, and select the position of the transition point in the image. You can also increase or decrease the blending width of color to no color in the image. The images best suited for this effect are landscape images with light-colored or white skies. Objects projecting up into the sky may have to be masked before the effect is applied to avoid unwanted coloration.

◉ LENS FLARE

It's funny that we spent years trying to figure out ways to reduce lens flare, and now we have plug-in software designed to re-create it. Most of these plug-ins have a set of presets that assist you in creating your own lens flare. It's easy to create just about every type of lens flare you can imagine, complete with spikes, halos, and many other lighting artifacts. This popular plug-in has many controls to modify how the flare is displayed. Sliders allow you to control the focal length of lens used, modify the number of spikes, vary the type of glow, brightness, position, and color of the flare.

The best images in which to apply this effect are those that already have a sun in the sky so that you can place the flare over the sun for a natural

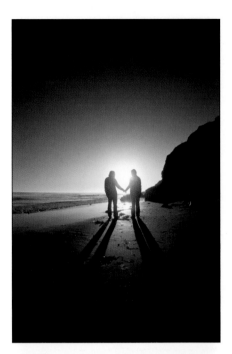

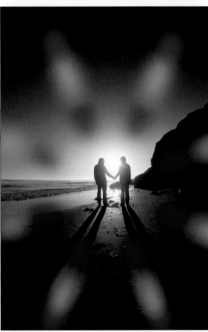

Top—Andromeda features the Diffraction plug-in filter, which converts beams of light into prismatic colors. **Bottom**—With the software adjustments you can control the quantity, width, length, and intensity of the beams of light. We highly recommend that you add a layer before you apply this filter. This layer can then be adjusted to slightly blur the effect.

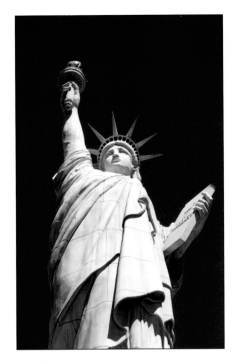

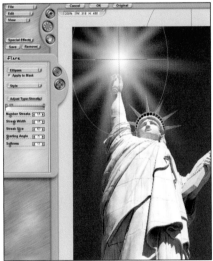

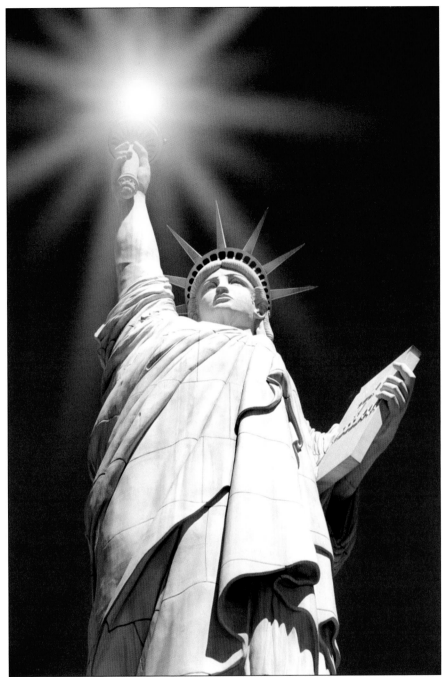

Top Left—This photo of the lady of liberty was taken in Las Vegas, Nevada, on a clear day with deep blue skies. **Bottom Left**—When you use the Mystical Lighting Flare filter from Auto FX, you have control over the number, size, and angle of the streaks of flare. You even have a control to adjust the color in the flare from the highlights to the shadows. **Right**—By applying this filter to the torch, Lady Liberty takes on a new look.

look. Other ideas for images can be open sky, where you can place the flare anywhere, or other bright light sources that could cause a lens to flare. If the lens flare covers up too much of the main subject in your picture, you can use one of the masking plug-ins to mask those objects and then apply the flare effect.

Vertical subjects projecting up toward the sky also make great sub-jects for this plug-in. One of the best we have seen is the Statue of Liberty. Simply place the lens flare over the torch, and you give it life and light.

● MOTION

A traditional motion filter usually consisted of a thick piece of uneven clear plastic that distorted the image at one edge. The thicker the plastic, the more motion effect was created.

Plug-in versions of the motion effect are designed to work on the entire image or objects floating as layers. With these filters, you can adjust the length of the motion, direction, how much the motion blurs at the end, and strength of the motion. Variations of the plug-in may also allow you to zoom the motion from a stationary position or from any direction.

We find that images with light-colored subjects on dark backgrounds lend themselves nicely to this effect. You can also use the selection tools to select specific subjects in a scene that are prone to motion, like a runner, horse, or car. Once your selection is a separate layer, then you can add motion to just that portion of the image.

● MULTI-IMAGE

The traditional multi-surfaced filter was permanently set to multiply a specific number of images from the original image as it passed through the filter. The most common results were a small image in the center with six to nine images that surrounded it.

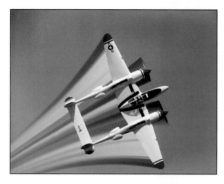

Left—This P-38 Lightning was photographed as it circled the airstrip. Although the plane was moving at high speed, the camera's shutter speed caused it to stop in mid-flight. **Right**—We wanted to put some movement back into the photo, so we first selected the background using the Magic Wand tool. By using the reverse select option, we now had the plane isolated from the background. We then applied the Motion Trail plug-in within Eye Candy 4000 from Alien Skin. With this plug-in you have control of the length of the trail, taper, and opacity. The key is to use the direction rotating dial to align the taper with the direction of the plane.

Auto FX Dream Suite's Directional Focus filter blurs the edges in a specific direction, creating the appearance of motion. A circular control allows you to select the area of sharp focus and the amount of blurring.

Top and Above—The Circular Multiple Image filter from Andromeda takes a photo and multiplies it to create from two to twenty images that circle the original. Control sliders allow you to adjust the radius of the circle, the size of each cell, and the intensity or opacity of the image. **Right**—Mystical Lighting from AutoFX features the option of adding a rainbow to any image. You can adjust the intensity, color, direction, or starting and ending points.

The plug-in version of this filter is very close to its glass counterpart, except that you now have dozens of options, many which could not have been done with the glass version. Adjusting the sliders can change the proportion of each image to the center, or even move the middle image off-center. You can even feather the border between images for smoother transitions.

The best photos to use with this effect are those with light-colored subjects on dark backgrounds. We find that flowers and airplanes in flight are a good place to start.

● RAINBOW

The traditional rainbow glass filters are rare and function very much like diffraction filters. While they really don't give you a true rainbow effect, the plug-in version does an excellent job. Sliders for this plug-in enable you to adjust the strength, size, angle, and position of the rainbow. Some of the more complex plug-ins may even have the ability to create a pot of gold, or double or triple versions of the effect.

We even found one rainbow filter where you could bend the rainbow into any shape you wanted. If you put an object at the end of the shaped rainbow, it would have the appearance of directional motion. We find that landscapes, waterfalls, and other subjects with dark backgrounds work best with this effect.

● POLARIZER

One of the most common glass filters found in a photographer's camera bag is a polarizer. The polarizer can reduce or remove distracting reflections or make colors appear more saturated. The biggest problem with these filters is that they are very expensive, and you may have to have several if you own different focal length lenses. Many of the digital point & shoot cameras do not even have the option of adding polarizing filters, so those photographers are out of luck.

Well, maybe not, as there are plug-in filters that do an excellent job of simulating the effects of a traditional polarizing filter. They mimic the real filter by featuring slider controls that rotate and adjust the density of the polarizing effect. This is a great plug-in as you can now go back and add saturation to those light-blue-sky images and polarize them long after they were taken. This plug-in is a must for anyone working with landscape images.

● REPEATER

The repeater is another rare glass filter that has several ridges that diffract the image slightly as it passes through the filter. The result is that the filter takes the primary subject in the image and duplicates it in several steps across the image plane.

The plug-in version of the traditional filter is also quite rare, but we were able to locate a couple. With this filter, you are given the option of

Top—The exposure range of this beach scene was too great to be captured on film. **Above**—Using the nik multimedia Graduated plug-in filter, you can add density and color back into areas of the photo that have been overexposed. We had the choice of preset selections, but opted to choose our own variations.

Top Left—This image of Mt. Hood, Oregon was taken without a camera polarizing filter. **Top Right**—We added the Polarization filter from nik multimedia. Software controls simulate its photographic counterpart by allowing you to rotate the filter to polarize the light. You can adjust the strength of the plug-in filter, which gives you more control than the traditional photo filter. **Above**—This photo was created using the Straight Multiple Image plug-in filter from Andromeda. This effect works best with a simple image on a plain background. The filter takes your subject and repeats it multiple times, creating the feeling of motion. You have control over the number of repeats, the spacing, and the intensity.

deciding how many facets, width of facet, angle, and the opacity of the filter over the background.

We found that a great subject for use with this plug-in is a single, simple subject that is known for its mobility. Select the subject (isolating it from the background) using a masking plug-in, and then apply the repeater to provide a feeling of motion.

● POSTERIZATION

Traditional posterizations were black & white photos with surrealistic variations of red, green, yellow, and blue. This effect was accomplished in the darkroom using orthochromatic film, pin-registered devices, enlargers, and a great deal of patience.

The plug-in version is one of the first creative plug-in filters that we ever used. Today, most of the plug-ins labeled posterization are not the photographic type, but rather a printer's version that reduces an image from 17 million colors to just a few.

The plug-in that truly emulates a photographic type of posterization allows you to replace shades of white or gray with any color your heart desires. So, if you want the bizarre and vibrant colors of a photographic posterization, then you will have to look for plug-ins with names like Seudocolor, Infrared, Pop Art, Colorwarp, and others. With these plug-ins you can assign a specific number of colors, designate exactly what colors are used, and the saturation level of the colors.

We always enjoyed the results we obtained from our traditional posterizations, despite the painstaking effort involved in producing them. Now, with plug-ins it is painless and loads of fun. There are plenty of super subjects for these surrealistic creations, but we have had great posterization success using old barns, bridges, and other structures demonstrating excessive image detail.

Left—This x-ray has been converted to a 256-step grayscale image. **Right**—This is the first image we used with a plug-in filter many years ago. It was called Pseudo Color from Aldus Photostyler, a company that was later purchased by the Adobe Corporation. Adobe discontinued sales of the filter and resurrected it in the Image>Adjustment>Gradient Map menu. A similar effect can also be created with Pop Art from The Plug-in Galaxy.

Above Left and Right—The reflection plug-in can be used to mirror one side of a subject's face for surprising results. **Left**—You can easily add reflections to any image using the Reflection plug-in filter from Andromeda. With this filter you can control the point where the reflection begins and the intensity of the effect.

⦿ REFLECTION

Over the years we encountered only a couple of commercially made mirrors or reflection filters, as most photographers tended to create their own. The results from each method were not always predictable unless you stopped the lens aperture down and previewed the results of the depth of field.

The plug-in version merely takes the part of the image that you want to mirror or reflect, copies it to memory, and pastes it in reverse and upside down. The software allows you to precisely place the edge of the mirror at a specific angle and intensity. You can have a perfect reflection or one that blends with the nonreflecting half. This is a great effect to use on old buildings. You can create a great mood by setting the lower reflection with a slightly lower density than the upper portion.

You might think that a person's face is the same on both sides, but if you apply this filter, you may find that

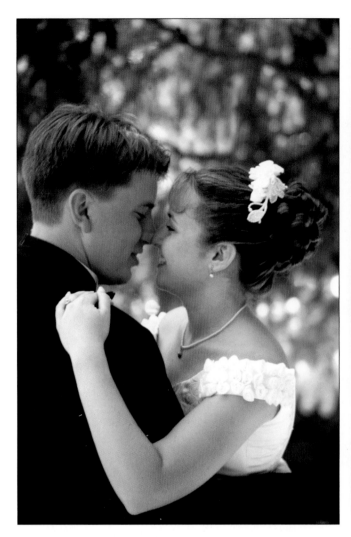
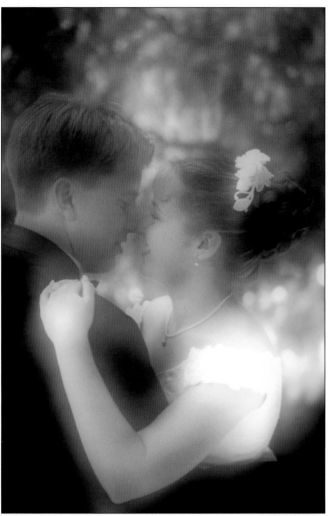

Left—Although this photograph from a lovely outdoor wedding captures the essence of the day, it lacks the mood of the moment. **Right**—The easy-to-use Scatter Light filter was used to enhance the mood. A member of the most recent filter bundle from Andromeda, it works using six different preset groups. Once you make your selection, you are given various options that simulate different degrees of soft focus and lighting. Layers should be used to allow for more control over the intensity of the effect.

isn't the case. By taking a person's face and placing a vertical mirror using this filter, the left side of the face becomes the right, or vice versa. Give it a try and you might be surprised.

● SOFT FOCUS

Portrait and landscape photographers have always depended on either soft focus camera lenses or camera filters to achieve a soft focus effect. The lens offered more control over how much and where the focus would appear in the image. The filter came in different strengths in order to vary the effect,

so you often had to purchase more than one to achieve satisfaction. The results from both options were irreversible and often caused less than desirable results.

Plug-in filters that are designed to achieve soft focus allow you to take any image and apply varying degrees of soft focus. Best of all, you can apply these filters to the entire image or just a small portion.

In order to make it easy to use these filters, they generally include preset variables that closely simulate what you would have achieved using a

soft focus lens or camera filter. They even have some presets that emulate the depth of field offered by certain camera f/stops.

● SOLARIZATION

Solarization is another old special effect that was accomplished after many hours in the darkroom. The effect was achieved by partially exposing a print, processing it, and adding more doses of exposure and further processing. The final print was a mixture of dark highlights and light shadows. Each print was different, and it required

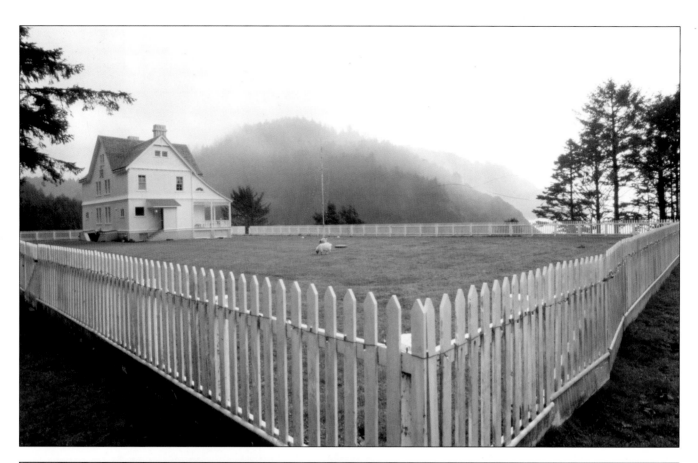

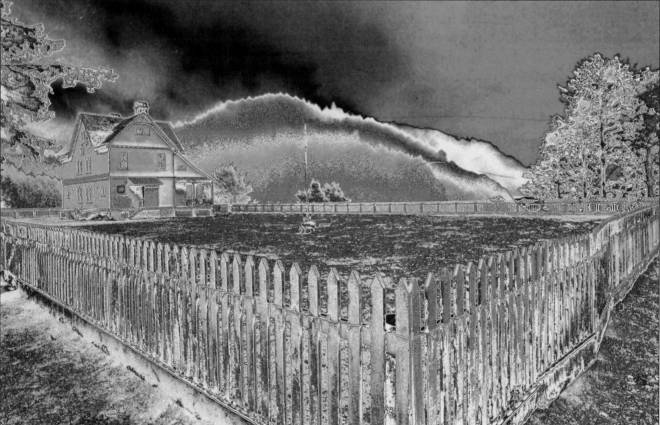

We applied the Fusion filter from The Plugin Site's Galaxy filter group to this hisorical home on the Oregon coast. This unique filter combines solarization and posterization into one effect. You have control over the image detail, RGB color intensity, and exposure.

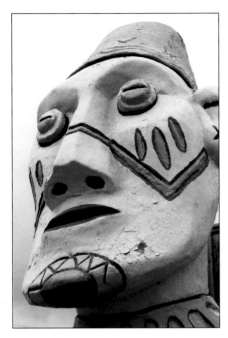

Above—Although this a very striking image, we decided to exaggerate the colors further by applying a solarization effect. **Right**—The solarized effect was created using an internal Photoshop filter. You access this filter by selecting the Filter>Stylize>Solarize menu. When this filter is selected, it is immediately applied to the image and you have no control over its effect. We have found that often the results are dark, so you will need to make an adjustment using the Image>Adjust>Auto Contrast function.

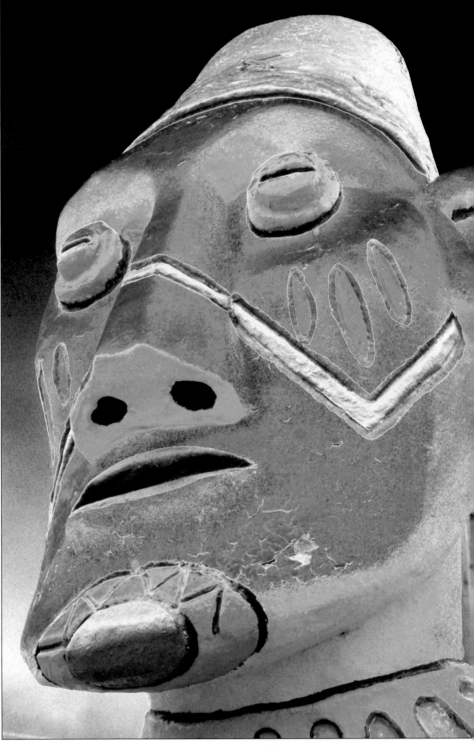

many tries before you got the results you wanted.

The plug-in version is one of the first photographic creative plug-ins introduced with the installation of Adobe's products. Both Photoshop and Elements offer no control over the results, as each program immediately applies the effect when selected. That's really not a problem though, as you can then easily adjust the image further using the Levels editor and Contrast or Saturation controls.

Of the thousands of plug-ins we reviewed, we found only a couple of solarization listings. Their advantage over Adobe's internal filter is the plug-ins offer additional controls to regulate development time and other methods similar to those once used in the darkroom. Solarization plug-ins offer great creative potential and let you save special settings so the desired results can be duplicated from one image to the next.

The best type of image for a solarization attempt is one with a higher than normal contrast range. In some cases, you may even want to increase the contrast level in Photoshop before applying the filter.

VIDEO

Video effects captured with traditional photography were produced by photographing a television screen using different focal lengths and shutter speeds. Usually this was done so that the photographer could eliminate the scanned effects of the video screen.

The video plug-in is used to accomplish the reverse effect. With this filter you take a normal image and run it through the plug-in so that the results look like it was taken directly off a TV set. Creative options usually include controls to adjust scan lines, rounded edges, distortions, and color shifts. This type of effect will work well on most any image, and is often used for print and digital presentations to simulate video.

BLACK & WHITE FILTERS

Over the years, black & white photographers have used a series of red, green, yellow, and orange filters to bias the colors that were being recorded as tones of gray. Red, orange, and yellow filters were used to increase contrast and darken skies. Portrait photographers used green filters to lighten foliage and create darker skin tones. Much experimentation was required to get the right effect.

The B/W Conversion filter from nik multimedia simulates this effect and provides more control over the final results than you ever dreamed. The process is simple and will work with any color image whether from film, print, or a digital file. Just open the plug-in and adjust the brightness, strength of the filter, and finally select from one of nik's 360 color spectrum variations. The advantage is that you

Left—One of the advantages to digital imaging is that you can convert color photos to black & white using plug-in filters. **Right**—The B/W Conversion filter from nik multimedia allows you to adjust the image brightness and strength of the filter. Best of all, nik multimedia has designed 360 filters, each representing a point in the visible color spectrum, that can be used to bias the black & white conversion.

can now shoot your original in color, and then make as many black & white variations as you want with this plug-in. You can even customize filter combinations and save the setting as a new file name for future use.

We even found a professional-level black & white filter plug-in—the Convert to B/W Pro from the Imaging Factory—that had color response settings for more than half a dozen black & white films. Simply select the film and filter you want to simulate, and the plug-in converts the color image to match those specifications. It even featured settings to

Top—This image was taken late in the day, which resulted in deep shadows. It also has a busy background that is distracting. Above—The background was carefully selected using the Magnetic Lasso tool and then feathered two points. We then applied Light Caster from AutoFX Mystical Lighting, which created soft beams of light that diffused the background, creating a very appealing wedding photo.

mimic the results of printing the image using multi-grade papers.

● LIGHTING EFFECTS

Lighting control, whether photographed on location or in the studio, has always made the critical difference between a standard photo and a professional one. Photographers struggled and sometimes even discovered that the lighting in the scene was not what was finally recorded on the film. Digital cameras today allow you to quickly review your images and try it again if something isn't just right. However, there are situations when your time, subject, or resources don't permit you to accomplish the lighting you intended. Are you just out of luck? No, not at all, thank goodness. Some of the new, high-tech commercial plug-ins give you the ability to alter the lighting after the fact. These

To achieve this dramatic image, Auto FX Mystical Lighting's Intense Light Brush was used. This filter intensifies the light source and adds saturation to any existing light.

plug-ins even have the ability to add a variety of light beams to the scene that were not there originally. Now you can create results like they do in Hollywood. It's easy to add beams of light to a lighthouse, flashlight, or to filter beams of light down onto a forest floor.

These plug-ins generally work with layers for added control and allow you to adjust the type of beam, angle, brightness, color, direction, and the degree of falloff. Be warned though that this type of plug-in uses a tremendous amount of memory and will require a very fast processor—and some patience.

The image in the lower right shows the original lighthouse. We used Extensis Mask Pro to select and mask the upper portion of the lighthouse. Light Caster from AutoFX Mystical Lighting was then used to create a narrow beam of light that simulated the lighthouse beacon. Since we had masked the upper portion, no light filtered onto that area, creating a realistic effect.

CREATIVE IMAGE FILTERS

Until now we have been discussing computerized effects that parallel effects that can be created with traditional photographic tools. Now we'll venture into computerized effects considered to be extremely difficult or virtually impossible to achieve with traditional photo equipment. Some of these effects were not even possible with computer systems until recent advancements were made in memory usage and processor speed.

There are so many types of creative effects that we had a tough time trying to choose which ones to cover in this book. Our selection of these filters is so extensive that discussions on them will begin in this chapter but won't conclude until chapter 13. If you can't find a specific type of effect, don't worry as it probably does exist, we just didn't have enough room to cover it in this book. Somewhere out there you will be able to locate a manufacturer, so take a look at our last chapter on related Web sites. Hang on tight, as we are going to take you on a wild and wacky ride as we venture into the zany world of computerized creative plug-ins.

THREE-DIMENSIONAL EFFECTS
Until recently the ability to create three-dimensional effects was restricted to using very large and complex stand-alone software programs. Increased interest by two-dimensional users looking to move up to creating three-dimensional effects challenged manufacturers to fabricate a whole new batch of plug-ins.

Because of the processor power needed to create three-dimensional images, these plug-ins are limited to just a couple of areas. The most common type is the manipulation of a two-dimensional image so that it appears three-dimensional. The second and newest type of plug-in manipulates three-dimensional objects and allows them to be overlaid on a two-dimensional image.

There is so much new interest in the three-dimensional world that when we look into our crystal ball, we can foresee a full working three-dimensional version of Photoshop in the near future. Until then, image editors working with 3-D will have to work back and forth between the three-dimensional stand-alone programs and the limited three-dimensional editing potential of plug-ins in Photoshop.

PERSPECTIVE
In Photoshop, the perspective of a two-dimensional image can be changed by using either the Selection

A selection of stock images were pasted into a stamp template, each as a separate layer, and brought into KTP Projector, from Corel Corporation. Drop shadows were added using Alien Skin's Shadowlab plug-in. The images were then rotated, scaled, and zoomed in KTP Projector to create this three-dimensional floating effect.

or Layers Transform commands. Small handles at each corner allow you to twist and turn the two-dimensional image at angles as though it were a three-dimensional object.

A perspective plug-in makes your two-dimensional image appear as if it were laying down in the scene. The problem is that too much twisting and turning of the image will result in loss of image quality at the editing points closest to you.

The third party plug-in versions usually have their own editing screen that enables real-time previews that give you a greater degree of control over rotation and skewing of the image. Some of the more advanced versions even have tilting and mirroring functions that can be added to the effect.

● SHADOWS

When you place objects as a layer in a photographic image, they looked faked. The amateurish look is because the object doesn't have a shadow like all the other objects in the scene. To get the three-dimensional look back, you can apply one of the several types of plug-ins designed to solve this problem.

Once you open the plug-in and select the object, you will be given choices for determining the length and direction of the new shadow. Care must be taken to ensure that the shadows match those in the remaining part of the image. In addition, the softness and opacity of the shadow must also match the other shadows in the scene. For example, on a bright, sunny day, the sun will create sharp, crisp shadows, while a partly overcast day will cause the appearance of soft and subdued shadows.

Some of the more advanced shadow plug-ins will have direct drag-and-drop control over the shadow. With this type of plug-in, you can move the shadow to a new position and use small control handles to change its overall shape. Most shadow plug-ins will have the ability to save settings so that you can repeat the task with other objects as you add them.

● SPHERES AND THREE-DIMENSIONAL OBJECTS

The most recent highlight in the three-dimensional plug-in world is that you can now actually import three-dimensional objects into Photoshop. Plug-ins like Corel's KPT6 Scene Builder allow you to manipulate the object as though you were working in a full-blown, three-dimensional editing program. Such plug-ins offer extreme versatility because you can control rotation, camera angle, lighting, and even texture. The most popular object for manipulation with these plug-ins is text, and we'll talk more about text plug-ins a little later.

Another common object used in these plug-ins is the sphere. In fact, it is so common that there are several plug-in programs that *only* generate spheres. That's okay, because they enable you to render just about every type of sphere you can imagine. One program has the ability to create movable lights, texture, and even bump maps to give a real three-dimensional appearance. Another plug-in will create multiple spheres that are transparent or can be coated with a two-dimensional image. You can even customize your sphere if you import your own image textures and use them instead of the ones in the supplied texture library.

Top—This shows the Extensis PhotoCast Shadow editing menu and the word shadows as a text layer. The control points allow you to stretch and elongate the shadow to emulate exaggerated lighting. **Above**—By adjusting the perspective blur, the trailing edges of the word are diffused.

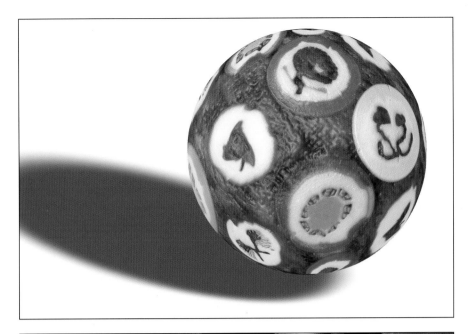

Above—This is a stock image of flat hard candy photographed in the studio. **Top Left**—This image illustrates the effect of applying the 3D plug-in from Andromeda. It wraps the two-dimensional image of candy around a three-dimensional sphere. A drop shadow was then added using Extensis PhotoCast Shadow. **Bottom Left**—Ulead Particle Effects uses eight preset groups to create various special effects. We have selected the Bubbles effect, which reflects the building in each randomly placed transparent sphere.

If you do use the three-dimensional plug-in on a generated object such as a sphere, we highly recommend that you create a new layer. That way you can easily apply other plug-in effects, like adding shadows, and complete the final desired three-dimensional effect.

With the increased interest in the three-dimensional imaging world, we think that many new plug-ins in this evolving area will soon appear.

7

BRUSHES

In the more recent versions of Photoshop, additional brush shapes have been added to aid the artistically inclined image editor. Many of the brushes resemble those that painters use on canvas, while others are cookie cutter shapes that can be sprayed onto your electronic canvas.

Even with these tools, Photoshop is limited on how much it can do with brushes, as it must devote its power to so many other functions. A couple of the third party plug-in manufacturers saw the shortcoming and have created entire programs devoted to the use of brushes in Photoshop. Some of their programs are so large that when selected, they minimize Photoshop and jump into their own image editor for efficiency.

● PAINTBRUSH

The first type of program expands the shape library to include hundreds of realistic shapes, complete with real-world textures, bevels, shininess, and shadows to give the brushes a three-dimensional appearance. In the plug-in programs we have tried, we found construction materials, metal, plastic, fabric, leaves, trees, clouds, insects, and others. In short, there are more variations than we can list.

The lighting for these brushes is controlled with a special menu similar to those found in a three-dimensional editing program. You can add lights, change their intensity, and even select the direction the light will fall on the brush strokes as you add them to the canvas. Best of all, most of these plug-in programs are compatible with pen and tablet accessories.

● IMAGE SPRAY

A very unusual and fun variation of the brush plug-in is called the image spray. It takes a collection of small objects and sprays them with a hose onto the screen as a layer. The collection may be ten to thirty different types of leaves, butterflies, different

Top Left—There are hundreds of brush options available with Right Hemisphere's Deep Paint Brush Strokes. In addition, you can add three-dimensional depth to the brushes by adding shadows and beveling. **Top Right**—This unique building is the local village church on the Fijian island of Gai. **Above**—A new layer was created and then Right Hemisphere's Deep Paint 3D Furry Cloner brush was used to create an abstract painting of the church.

Top Left—We took a group of twenty stock images and pasted them into slide mounts that were evenly arranged on the screen. This group of mounts was collected and a brush was created in Image Spray from Human Software. A blank image was opened and this brush was selected to spray the mounts onto the screen in a random order. **Bottom Left**—Fourteen fish photos were selected from their original backgrounds and pasted evenly in one new image. All were selected and used to create a Human Software Image Spray brush. The brush was applied on a blank image in a circular pattern. We varied the width of the brush so that the larger images were in the center and slowly tapered in size toward the edges.

Above—Thirty-six boxes of film were evenly arranged and then selected to create a Human Software Image Spray brush. A new image with a white background was made, and the words "Film Test" were typed in black bold letters. The Image Spray of film boxes was used to carefully trace around the text. The white background was then selected, and the Graduated Fill in Photoshop was applied.

pieces of candy, or who know what else. We found only a couple of these programs, but they had hundreds of objects that could be sprayed onto your electronic palette. In addition, these programs have special editors that allow you to collect a series of similar objects and create your own personal spray collection.

We thought that feature would come in handy, so we created a fish spray from some of our underwater images. Best of all, the process was actually quite simple. We first copied and pasted fourteen different fish onto a plain black background. We then arranged them so that they fit evenly on a grid of five across and four down. The black background was then selected and we reverse selected the fish. The program then created a grid of twenty images that could be used to spray on a picture.

We then saved the selection, which created a mask or alpha channel. A white shadow was added to the alpha channel, and then we saved the entire image as a TIFF or PSD file. This collection of masked images could then be loaded into the image spray plug-in and scattered onto an image canvas.

There are various controls with this type of plug-in that will allow you to spray images in order, randomly, with rotation, at different sizes, and with varying spacing between the images. We even found one plug-in that allows you to add bevels and lighting to each of the images in the spray. Cool, huh?

8

ELEMENTS

In order to bring more realism to your images, you can employ one of the many plug-in groups that include programs used to simulate natural phenomena. Fire, water, smoke, snow, and lightning can now be added to existing photos. In the early versions of these plug-ins, it was easy for viewers to tell that the effect was created on a computer, but this is not the case anymore.

Most of these effects have extensive slider or dial controls to provide maximum adjustment capability. In some cases, objects in a scene are first selected and feathered before the natural effect is applied. Other effects are applied directly to the entire image.

● FIRE

The fire plug-in from Alien Skin Eye Candy 4000 is designed to set fire to the entire image or to selected objects in the scene. When the fire plug-in menu opens, you are given controls to adjust the flame intensity, height, and width. You can even modify how the flame is affected by outside forces, such as wind. In most cases, you will also have the option of having flames restricted to outside the selection or to the feathered area inside.

If the plug-in does not have an intensity or opacity setting, you can always add a new layer to the image

before you apply the effect. Then you can control the fire with Photoshop's Layer controls. This effect works very well with images that have selected sections of old building or trees.

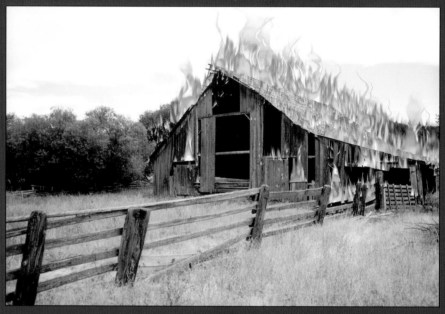

Using the Magic Wand and Lasso tools, the barn was selected. We then applied the Fire plug-in from Alien Skin Eye Candy 4000. We weren't totally satisfied with the results, so we added the Smoke filter for added effect.

● SMOKE

If you have already set an object on fire with the fire plug-in, you might consider using the smoke plug-in to add an increased element of reality to the image. Most of the variations with this plug-in require that you first select a specific area or add a new layer before the effect can be applied. The control menu allows you to adjust the thickness, height, and turbulence of the smoke as it rises.

With most of our attempts in using this filter, we found the smoke too dense and not very realistic. That was not a problem since we used the functions of Photoshop Layers to adjust the density. We also found that applying a soft focus or blurring plug-in to the smoke layer improved the overall effect of the smoke. This effect works best on images similar to the ones that lend themselves well to the fire effect.

● FOG

Attempts were made with traditional camera filters to simulate the effects of fog, but they were never very successful. The computer plug-in version

uses some very advanced techniques for creating wispy layers of fog. These menus will usually give you control over fog density, height, and randomness of the fog bank in the scene. In some of the more advanced fog plug-in programs, you can even move sections of the fog so that a mountain peaks through the fog or a building partially appears through the fog bank. This is a great effect for photos of landscapes, especially those with mountains and hills.

● ICE

Most ice plug-ins that we found were designed to coat the surface of the image with an icy texture. When using this filter, you can apply the effect to selected objects, but we found that it looks better if you apply the effect to the entire image. In most cases, you will have only a couple of controls to adjust the density of the ice and the randomness of the fractures in the ice. Images of subjects with smooth surfaces work very well with this plug-in.

● LIGHTNING

For a long time, the only way to create lightning in an image was to photograph the real thing. Some of the problems associated with this dramatic show from Mother Nature were inclement weather and critical timing, and you were just plain lucky if you were in the right spot at the right time when the strike occurred.

With the lightning plug-in filters, you now can create your own lightning bolts in the comfort of your home, with no fear of getting zapped. Most of the programs we have reviewed have similar features. They usually allow you to designate a starting and ending point for the lightning. This makes it easy to have a bolt of lighting streak down from the sky and strike a specific point on a building or tree. Other adjustments include control of the brightness of the strike,

Top—Alien Skin Xenofex Lightning gives you the awesome power to mimic Mother Nature. You can simulate lightning, as this plug-in provides control over the starting and stopping point of the bolt. Additional adjustments can be made to the glow, width, and amount of forks that extrude from the lightning bolt. **Right**—This cute image has a very distracting background, but not to worry—we have a cure. **Far Right**—The background was selected using Extensis Mask Pro and feathered with the feathering tool in Photoshop. The Corel KPT Sky Effect was then applied to this selection. The KPT Lens Flare was applied to add a bit of sparkle to the bubble.

branching thickness and spread, and the glow created by the strike.

Of course, the best images for this effect are outdoor scenes with a dark sky and buildings or trees that might be hit during a real storm.

● SKY EFFECTS

For those photos with great subject matter but lousy skies, there is now hope. These new plug-ins allow you to doctor a less than spectacular sky with the addition of clouds, blue sky, and even large sun orbs. The key to

making this type of plug-in work well is to select just the background sky area and feather it slightly before applying new sky effects.

Make sure that you select all the sky area, as some of it could be hidden between leaves and branches. If there are many small sky areas to select, you should consider using the Color Range selecting tool. This tool will

automatically select all colors and densities similar to the sky area you want to select. If you have accidentally selected areas other than the sky, you can use the minus Lasso selection to remove unwanted selections.

This type of plug-in features some very sophisticated controls that allow you to add haze, fog, clouds, and even position a new setting sun. One pro-

gram that we tested even had the ability to add the moon to an image. Care must be taken not to create scenes that are not physically possible, like a fully lit moon positioned next to the sun (unless you are creating images that are out this world). The best images for this plug-in are those with light-colored skies that can be easily selected and feathered.

● SNOW AND RAIN

Want to change your fair weather image to inclement weather? Try the snow or rain plug-ins. Controls for these two plug-ins allow you to vary the density, direction, and size of the particles. The size of the original image will affect the size of the snowflakes or rain drops, so care must be taken to ensure that they look realistic. We also suggest that you apply the effect to a new layer so that you can make additional adjustments to the opacity and sharpness of the particles as needed.

● TREES

This plug-in is ideal for all types of landscape photography. When the program opens, you are given a choice of tree type, branch variations, and leaf options. You can also add shadows that match the ones on other objects in the scene. It is best to put your tree on a separate layer so that you can apply other filters that will aid in ensuring that the tree blends into the background. Since this plug-in is memory intensive, it features a wireframe option that enables you to position your selection before rendering.

The original image featured a horse in the foreground and an old barn in the distance. We decided to add a tree for perspective using Digital Elements Verdant. A shadow was added that closely matched that cast by the horse. In addition, we used Image Factory's Graduated Fog to enhance the early morning effect.

● WATER

For some reason, the plug-in industry has a great fascination with water plug-ins. There are plenty of them on the market to choose from, and you'll find many variations too. Let's first take a look at the reflection variation. In truth, this plug-in works well with reflections from mirrors and glass, not just with water, although the most common use is water. Menu controls allow you to create sharp or soft reflections or to layer the image so that part of the original comes through the reflection. We even found a water reflection plug-in that creates rings as though something had been thrown into the water.

Facing Page—Digital Elements Verdant was used to create a weeping tree in this field of clover. **Top**—This peaceful scene in Oregon has been interrupted using the Ripple filter from AutoFX Dream Suite. **Above**—Original image.

Flood. One of the most unusual water plug-ins we have ever seen is only made by a couple of companies. The flood plug-in raises the flood waters in the scene to any level. This plug-in creates images that look very realistic with correct perspective, reflections, lighting, and wave motion.

This is one of our favorite plug-ins. We love to flood buildings, trees, and landscapes. When you apply this filter to buildings on dry land, it gives the appearance of water actually running through the doors and windows, depending on the height of the flood.

Right—This old vacant farm house was once Jack's father's home in Iowa. **Above**—Using Flaming Pear's Flood filter, we were able to simulate the hundred-year flood. This unique filter offers its user control over the water level, reflections, and wave action.

FRACTAL IMAGING

This is one of the earliest plug-ins available on the market. Images created with fractal plug-ins are based on hundreds of mathematical formulas that create alien-colored, shaped landscapes. Each plug-in comes with mapping controls, formulas, and settings that give you millions of detail variations. Most of the plug-ins in this group do not need an original image to work with. In most cases, you can open a blank image and then apply the effect. Almost all variations of this plug-in have a very large library of preset images or formulas to get you started.

An interesting control called time and motion has been added to the new versions of the plug-in. This time and motion viewer allows you to slowly see the fractal image changing from one shape and color to another as it randomly varies its formula. You can start or stop the effect at any time and

This colorful image was created using Corel Corporation's KPT FraxPlorer and a blank screen. You can vary each image by adjusting any of the presets, color gradient, and style while moving your position in the mapper. Four other images created with this plug-in are found at the top of the following page.

save your creation as a still image. If you click on the main image, you will begin to zoom in on the fractal image and will continue to do so until you click on the image again. This plug-in is strictly an oddity in the plug-in world and produces more of a pop art effect than anything else.

Recently, a three-dimensional version of fractal plug-ins has surfaced that takes the fractal information and converts it into a three-dimensional model. This fractal shape can then be coated with a reflection of another scene or a group of texture files. Most of the resulting images look like pieces of volcanic glass or meteorites.

This plug-in, called KPT Frax4D from Corel, takes two-dimensional fractal images and adds a third dimension. Since you now work in the x, y, and z axes, their combinations provide multiple maps in which to move your position.

SURFACES

Both Photoshop and Elements have several dozen surface effect plug-ins that come standard with the programs' installation. Most have a small thumbnail viewer and a couple of sliders that can tweak the impact of the effect.

Since the Photoshop users want even more options, third party software manufacturers have created plug-ins that are applied to the image surface. This is one of the largest groups of creative plug-in we have seen, with several thousand different variations. Most of these effects take a two-dimensional image and add effects to the surface so that it takes on the look of a three-dimensional image.

These creative effects are accomplished by combinations of bevels, lighting, selections, layers, and textures. They usually are applied to the entire image or just the edge of the image. Since an edge effect is normally designed as an output function, we will mention them, but will cover them in depth in chapter 14, the output plug-in filter section.

● BEVEL

The Bevel plug-in filter takes selected objects, or the edge of an image, and applies an effect that creates highlights and shadows. The result is a beveled edge effect that give the viewer the impression that they are looking at a three-dimensional image. There are slider controls that can increase or decrease the depth of the bevels by adjustments to the shadows and lighting. Bevels can also be forced to follow the inside, center, or outside of a selection.

The most common use of bevels is with three-dimensional text, which is covered in the next chapter. Images with bright highlights and fine lines make the most interesting subjects for beveling. Photo reflections on the bevel can be imported from image libraries that come with the bevel plug-in, or you can use your own personal stock images. You can then mix the color of the bevel with the imported image to create objects that have a unique appearance.

● CRACK, CRUMPLE, TEAR, BURN

For years we have safeguarded our family albums for fear that they would be damaged. Now there are plug-ins that create the appearance of ill fate to your photographic prints, but without actually damaging them.

We have grouped these plug-ins together since they all have similar functions and are generally applied to the entire image without requiring object selection. Each of these plug-

Basic black shapes were drawn using Photoshop's Shape tool. Each shape was then selected away from the white background using the Magic Wand tool. Next, the KPT Shape Shifter from Corel was used to bevel and light each shape differently. We were given the choice of plastic and metal, reflection or refraction index of the objects. The rainbow colored lines were drawn with KPT Gels. This filter is great because it gives the feel of liquid flowing from every stroke of your pen or brush.

ins has a series of patterns stored in their program that is applied with bevels, lighting, and shadows so that the image appears to be cracked, crumpled, torn, or burned. It's amazing to open a tinted black & white family portrait and combine it with one of these plug-ins—you can literally sit back and witness the ravages of the passage of time.

Creating tears usually requires the use of two images. The top layered image is the one that will be torn, while the bottom image will serve as a background. If you want to restrict where the tear is to appear, you will first have to select the torn area on the top layer using the oval or lasso tools.

Top—AutoFX Dream Suite also includes the Crackle plug-in. When this surface is applied, it gives everything the appearance of instant aging. Areas of the image crack and fall off, leaving behind blank space. You can also use the Lasso tool to select certain areas that you would like to remove from the scene for effect. **Above Left**—The Alien Skin Xenofex Rip Open plug-in is used to make it appear as if something had punched through the photo. It requires two photos, one as a background and the other as the top layer. The effect is actually applied only to the top layer as the background remains stationary. You have control over the size of the rip and the degree of curl in the photo. **Above Right**—Alien Skin Xenofex Burnt Edges simulates your image being burned and scorched on the edges. You can control the degree of the burn area, the burn width, and the color of the background. The program can also add smoke damage for added effect. **Right**—With the Alien Skin Xenofex Crumple plug-in, you can take any photograph and light or bevel it to appear as if it were crumpled. It automatically creates an extended background so that the print edges can be torn for added effect. A drop shadow was applied using Alien Skin Eye Candy 4000 Shadowlab.

◉ EMBOSS

Another plug-in that dates back to the very beginning of image editing is the emboss filter. Emboss plug-ins convert both black & white or color images to white, gray, and black with a slight offset of the three. The results give the impression that the image was embossed with a metal embossing tool.

An excellent version of the emboss plug-in comes installed with Photoshop. Three controls give you adjustment over direction, depth, and strength of the embossed image. We find that buildings, lighthouses, or images with one or two very dominant lines are the best candidates for the emboss plug-in.

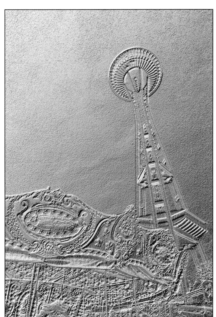

Top—Although the image on the left is a very dramatic photo in and of itself, we decided it was the perfect candidate for some creative manipulation (left). The Color Range tool was used to select the midtones in the photo. When this was accomplished, we applied the Gel plug-in filter from AutoFX Dream Suite. By selecting a preset color, the plug-in added bevels, highlights, and drop shadows to the selected areas (right). **Center**—This effect was accomplished using Photoshop's internal Emboss plug-in filter, which is located in the Filters>Stylize>Emboss menu. Although the effect is applied immediately upon selection, you still have some added control. You can adjust the direction of the shadows and highlights or correct the depth of the offset. **Bottom**—The Emboss plug-in works just as effectively using black & white photos as it does with color images.

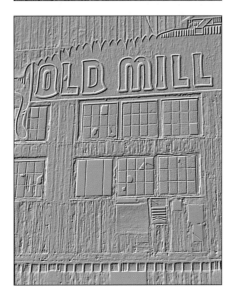

◉ FUR

This very strange plug-in actually grows fur in selected areas and along the edges of selected areas. We're not really sure where the need for such a filter arose, but that's also true of many of the other plug-ins we have collected. Even so, if you want to grow fur from someone's head, line the roof of a house, or use the effect to create a title for a presentation about furry animals, then this might be the plug-in for you. The controls

Top Left—This ceramic sculpture was photographed in our studio. **Bottom Left**—Here, Corel's KPT FiberOptix plug-in was used to create our very own Chia pet. With this filter, you have control over the lighting and can determine the fiber length or curl. **Above**—This plug-in, found in Photoshop, is called the Glass filter. It is located in the Filter>Distort>Glass menu. Your image takes on the appearance of being placed behind frosted glass. You can select the type of glass and the amount of distortion.

for growing fur include the type of hair, length of hair, hair color, lighting, and adjusting the tapered ends. The plug-in is most effective with objects selected out against a plain background.

◉ GLASS

If you wanted the look of layered glass over the top of your image without the glass actually being there, then this plug-in will accomplish that feat. This plug-in is available within both

Adobe Photoshop and Elements, as well as from several third party plug-in companies. This effect is accomplished through the use of bevels, lighting, and built-in glass patterns within the program. Depending on the type of effect you select, the glass may either cover the entire image or can be used just as an edge effect. We find that images of nature and flowers are a good starting place when trying this plug-in.

● METAL

There are two distinctly different types of plug-ins that are classified as metal filters. The bevel type of metal plug-in applies a chrome look to a selected area of the image, complete with shadows and highlights. Built-in reflections give the impression that the selected surface is made of a reflective metal. Color selections in the plug-in menu will determine which type of metal is represented.

The second type of metal plug-in looks much like an etched metal. The program combines a type of posterization and pattern creation in which the results have a pitted metal appearance.

The Andromeda Etch Tone plug-in simulates metal etching. You have control over the number of lines per inch, contrast, and the degree to which it blends with the background. It also contains its own sharpening presets to bias the effect.

Threshold controls determine the proportion of black to white in the shaded areas, while the lines per inch varies the image detail. Old black & white images of trains, ghost towns, and farm equipment are among the best candidates for use with this particular plug-in.

Facing Page and Above—The Alien Skin Xenofex Classic Mosaic plug-in breaks an image into tiles with grouted edges. Control sliders allow you to adjust the size of the tiles and the width and color of the grout. The original image is shown at the top of the page for comparison.

MOSAIC

This type of plug-in reduces the amount of colors in an image to make it manageable. It then breaks it down into small tile pieces. You can control the tile size, edge sensitivity, or grout width and color. The program also offers some presets to help you get started. The thumbnail preview allows you to see the effect as it happens.

Once you apply the filter, you may find that your end results are unsaturated and low in contrast. If you use the Photoshop Levels editor, you can modify your results to give your image more pizzazz.

PUZZLE

The first puzzle plug-ins just laid a puzzle pattern over an image. You

Above and Right—Another example of a mosaic effect. This one was created with the Baked Earth filter from Alien Skin.

could select specific pieces using the Photoshop selection tools and move pieces one at a time. The images were crude, but it was a start.

Today, the puzzle plug-ins are quite good. With these new software wonders, you can determine the size of the puzzle pieces, the width of the black spaces, and which pieces to remove. Bevels and lighting effects make the printed puzzle images look so realistic that you may well find yourself reaching out to select a puzzle piece.

Once the puzzle is drawn, it's easy to selectively remove any puzzle piece. Simply select a piece, and it is removed. It doesn't get much easier

than that. You can even put different backgrounds in the areas where the pieces have been removed.

Almost any type of image will work with a puzzle plug-in. If the plug-in has preset options, you can select from a wide assortment of stages of completion. We suggest that you start with images that have lighter colors so that you can see the edges of the individual backgrounds in the areas where the pieces have been removed.

● TAPE

This plug-in filter is designed to simulate the look of a photograph taped into a scrapbook. In order for the effect to work, the photo must be

smaller than the background, so that the tape will be visible beyond the edges of the print. The plug-in allows you to choose from such options as duct, transparent, masking, or sports tape, and you can adjust the tape's color or age. The filter features extensive controls that include wrinkles, tears, curl, perspective, and overlap adjustment. You may be able to find a scaled-down version of this plug-in included with some of the photographic edge effects in other plug-ins.

● WOOD

The wood plug-in is really a texture program that applies one of its many preset wood textures to either a select-

Left and Above—The Alien Skin Xenofex Puzzle plug-in allows you to separate an image into puzzle pieces. There are controls that enable you to adjust the size of the pieces, determine the background behind a piece, and select individual pieces for removal. There are multiple presets that show the puzzle in various stages of progress.

Above—The AutoFX Dream Suite Tape plug-in enables you to give your photo the appearance of being taped down. You will need to expand your canvas size to allow the tape to be visible on the background. **Right**—Select an area where you want to have the appearance of wood. Feather the selection slightly and then apply the Wood plug-in from Alien Skin Eye Candy 4000. The area will then be filled with the wood type that you have selected. You also have controls to adjust the amount and size of wood knots, tree ring thickness, and the color of the bark.

ed area or the entire image. You will find that most wood texture plug-ins have a small library of wood sections, but you can also pull from your own personal supply of stock images. Another option is to create your very own pattern, which will be discussed in chapter 12.

Be aware that if you want to apply the wood effect to the entire image, you should apply it to a new layer in the image. With a layer, you can con-trol the opacity of the wood detail and the original image. If you want to apply the effect to just a selected area, we recommend that you use a larger-than-normal feather selection.

With wood plug-ins, you can typi-cally control the type of wood that's applied and can adjust the knots, grain, and ring settings. Interesting effects can be done with black & white images converted to RGB, to which the wood plug-in is applied.

11

TEXT EFFECTS

In versions of Photoshop as far back as 2.5 for Windows, you had the option of laying text over the top of photographic images. At first, the process was crude, and the best you could hope for was to duplicate the original line of text and add colored outlines and shadows. Since that time, text in Photoshop has become very sophisticated. In addition to allowing you to directly type on the screen, you can pick from hundreds of fonts and scale the text to any size. In the more re-

This shows an actual application of Photoshop text. The drop shadow was added from the Styles menu.

cent versions of Photoshop, a text style menu allowed you to add bevels, shadows, glows, gradient fills, and stroke outlines. Adobe has done such a good job with its text controls and text effects that we found very few text plug-ins that could compete or augment the ones in Photoshop.

PHOTOSHOP'S INTERNAL TEXT PLUG-INS

Before we look at the third party versions, let's take a look at the text process in Photoshop so that we have a

better point of comparison. When you select the Type tool, you can proceed to type the text you want right on the screen. You can then position and size the text with the Move tool and the size controls at the top of the screen.

From there, you can go to the Layers pull-down menu and select a Blending Option. If you're not sure just what style you want, you can open the Window>Styles palette and use the available thumbnail version to help you make your choice. Once you see one you like, simply click on that

Top—This shows the Styles menu located in Photoshop. To access this menu go to the Window>Styles, and the library will open. Just select the style you like from the browser, and it is immediately applied to your text. **Bottom**—Here are some samples of Photoshop text styles. The text itself indicates the effect produced through each style.

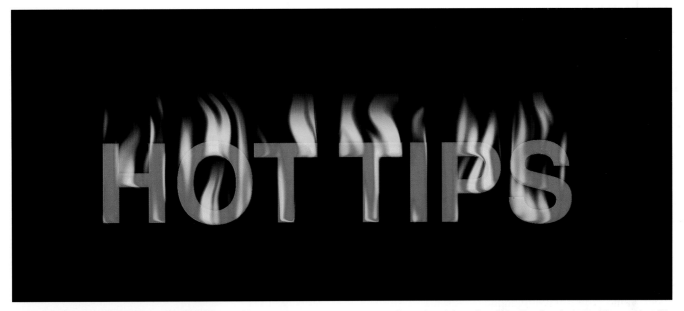

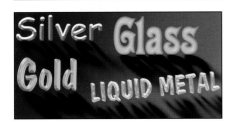

Above—The text was typed and selected and the Alien Skin Eye Candy 4000 Fire on Text filter was applied. Normally the flames go beyond the text, but you also have the option of allowing the flames to be inside your text. **Top Left**—Textissimo, from Human Software, features a large gallery of text effects that come with the software. Just select the one you want, and you can begin editing the text by adjusting the size, bevel, and color. You can also modify the text path and distort the letters to create your own unique font style. **Bottom Left**—Here are four different effects from Alien Skin Eye Candy 4000 Liquid Titles. The silver, gold, and liquid metal are all done with the Chrome plug-in, and the other title uses the Glass plug-in. All four titles were given drop shadows using Alien Skin Eye Candy 4000 Shadowlab.

style and it will instantly be applied to your selected text.

You can always modify the preset style by going back to the Layers> Styles>Blending Options pull-down menu and modifying shadows, bevels, glows, fills, or strokes that have been applied to the text. Besides all that, you can always add special effects from any of the third party plug-ins that offer features beyond those found in Photoshop.

⦿ THIRD PARTY TEXT PLUG-INS
The third party text plug-ins come in two types—2D and 3D. The 2D type uses methods very similar to Photoshop but has combined additional effects such as texture libraries, path editors, and dozens of blending effects, all found in one easy-to-use menu. Instead of typing the text

directly on the screen, your text is typed on a large thumbnail image. You can preview your work in progress as you work your way through the paths, textures, and make adjustments to the final text size and placement.

The second type of text plug-in is a three-dimensional text generator. Up until now, this has not been included as part of Photoshop, but this may change as new versions of the software become available. These three-dimensional text plug-ins work like those found in stand-alone three-dimensional modeling programs. Yes, you type in the text you want, but that's where the similarity to other text programs ends.

Since with 3-D you are working in the x, y, and z environment, you have full control over your text from every direction. You can bevel the text, ex-

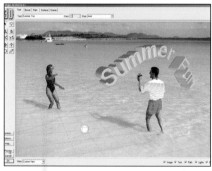

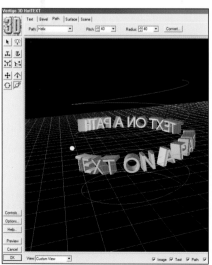

Above—An Alien Skin Eye Candy 4000 plug-in called Bevel Boss is designed to provide a three-dimensional appearance due to the addition of bevels. A special bevel curve editor allows you to customize the shape of the bevel, which can then be saved in your list of presets. A drop shadow was added using Alien Skin Eye Candy 4000 Shadowlab. **Top Left**—Vertigo 3D Hot Text allows you to easily create three-dimensional text overlays. This menu shows the path of the text and an icon indicating the direction of the light. There is a grid pattern to help you align the text on an x, y, and z axes. The grid pattern and lighting icons will all disappear in the final image. **Bottom Left**—The path editor in Vertigo 3D Hot Text provides you full control over the direction and rotation of your text. You can use any of the preset paths or design your own.

trude it, or light it from odd angles. Most important, you can rotate the text on the screen. There are no doubts about your lighting effects, as exact lighting control is accomplished in real time. As you move the lighting controls, the results are displayed directly on your editing screen.

You can even assign a path to the three-dimensional text, and it will contort to fit that shape. Colors can be assigned to the face and sides of the text, or you can import images and layer them on the surface of the text. All the time you are working with the three-dimensional text, your image is displayed in the background to ensure proper alignment.

The only downside to this type of plug-in is that with three-dimensional models, you must render a preview to see the final results. The complexity of your effect and processing speed of your computer determine how quickly your effect will render.

PATTERN MAKERS

Web page designers, art directors, and photo editors are constantly on the lookout for new and different types of background images. Providing unique images is the key to their being on the leading edge. They want a background that no one else is using for their application. As a result, we have texture and pattern generators that can create a myriad of background images for every type of application.

● PHOTOSHOP'S PATTERN MAKER PLUG-IN

More recent versions of Adobe Photoshop include a pattern maker plug-in (Filter>Pattern Maker) that allows you to make small selections from an image and create patterns. Slider controls allow you to set the size of the sample, adjust detail quality, offset for each pattern piece, and control the smoothness of the blend. The pattern can then be saved in the patterns menu and selected at a later time to be used as a fill option. The plug-in is quite good and gives you unlimited potential for creating your own background patterns.

● THIRD PARTY PATTERN MAKER PLUG-INS

Most all of the third party plug-ins that create this type of background image have a library of patterns for

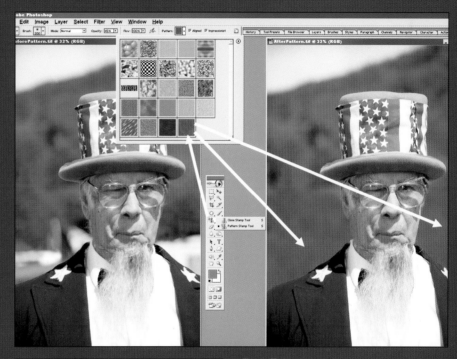

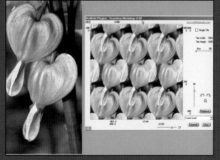

your initial selection. These programs offer slider control over the lighting and bevel adjustment to provide a three-dimensional effect. To ensure smoothness between each pattern part, you can feather the boundaries and shift the image data from one piece to the next.

Most of the pattern plug-ins give you controls for adjusting brightness, color, contrast, blending modes,

Top—This image illustrates an internal Photoshop plug-in that is located in Filter>Pattern Maker. We found the background in this image very distracting. We selected a small section of the background foliage and created our own pattern, then we saved it as a new preset. Using the Magnetic Lasso tool, we selected the area behind his shoulder and applied this new pattern to fill that area. **Left**—Redfield Seamless Workshop will allow you to take any image and create a seamless pattern. Here we have taken flowers and applied the Seamless Workshop to create a continuous pattern, making a unique background image.

opacity, and repeating mode. Additional controls allow you to rotate, shift, and blend the pattern into a background image. You can then save the new patterns with your own unique texture file name.

We even found a pattern plug-in that creates various types of camouflage. So, if you have a need to create some military-related images, there's a plug-in for you.

Top Left—Here are some sample patterns made with KPT Materializer. The key to this pattern generator is that it adds the power of beveling to the give the pattern a three-dimensional appearance. **Bottom Left**—This is a selection of patterns generated with Alien Skin Eye Candy 4000 Weave, Water Drops, and Swirl plug-ins. The cloud pattern was created with the Alien Skin Xenofex Little Fluffy Clouds plug-in. **Above**—You can use a blank image or a selected area in your photo to apply Camouflage from VDL Adrenaline. There are options that simulate military and hunting material, or you can modify them and save your own presets.

WARP AND DISTORTION

Image distortion is not new to Photoshop. It has been around ever since version 2.5 for Windows. Most of the original distortions were basic and fell into the category of straight line perspective distortion. Since that time, programmers have tried to find increasingly complex ways to distort images—all in the name of creativity.

● DISTORTION PLUG-INS

Third party distortion plug-ins come by many names, with Warp, Fun House, Goo, Swirl, Jiggle, Sphere, Zigzag, and Wave at the top of a very long list.

The first type of plug-in distortion affects the entire image or the image

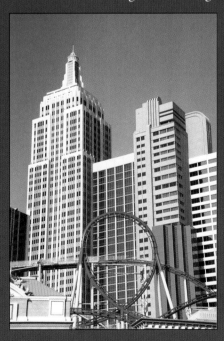

Left—Although this roller coaster ride is exciting, just hang on and we'll show you what our plug-ins can do. Right—We can now twist and turn the image from left to right using the Bulging Edge Twirl from the Filter Factory.

layers. With this effect you can twist and turn images so that the perspective of the image will have a three-dimensional look. If you use image layers, each layer can be distorted to different shapes and positions. The combination of multiple distorted layers can then give the appearance of many images layered on a horizontal plane. We even found a few of these programs with a video function that allowed you to follow the progress from no distortion to full distortion.

Another type of distortion plug-in works only on a specific area without affecting the rest of the image. One of the most common applications for this plug-in is to achieve facial distortion. To restrict your area of distortion, you can use any of the Photoshop selection tools. You can then distort small areas in an image with special tools like a magnet, smear, twirl, and a pinch. When each of these tools are touched to a specific point in the image and dragged in a direction, that section will move and distort to a new shape. Typical creative facial distortions include an enlarged nose, small eyes, or no chin.

Above—We found this colorful blue and gold Macaw at the zoo. **Right**—The VM Distortion Gear from the Filter Factory was applied for a unique effect. With this filter, you can control the quantity and length of the gear effect.

Above—Here's another of our friends from the zoo. Left—Using Photoshop's internal Liquify plug-in filter, this giraffe now has something to say. Two tools were used to create this effect. The Bloat tool was used to enlarge the mouth, while the Pucker tool was used to reduce the size of the neck. **Bottom Left and Right**—Here, Corel's KPT RadWarp filter was used to distort a portrait, giving this jester an even more jovial appearance.

● LIQUIFY PLUG-INS

The liquify plug-in, found in more recent versions of Photoshop, provides you with a considerable amount of control over distortions. A toolbox in the upper left corner allows you to twist, turn, zoom in, zoom out, and add turbulence to the brush you use to distort various sections of the image.

On the serious side, oral surgeons, crime scene investigators, and make-over technicians all use variations of these facial distortion programs to show before and after images. Most of these programs are sophisticated and expensive stand-alone programs.

Even so, you can do your own facial reconstruction with a little help

from one of these distortion plug-ins. This can be a great tool for those who want to create special gag images for greeting cards, posters, or parties.

● FEEDBACK PLUG-INS

A Feedback plug-in filter takes information from an image, duplicates a specific part, and places it back in the image as a distorted shape. The plug-in can repeat this effect over and over to provide a final image with a kaleidoscope effect.

Some of these filters have a vortex or tiling function that replicates itself over and over, getting smaller each time as it fades to infinity. This three-dimensional effect can be played out on a flat plane or in a spiral shape that tunnels off into the distance.

Almost any type of image is worth trying with this plug-in, but we suggest that you start with images containing round objects, like wheels. The circular shape seems to lend itself nicely to this effect and usually provides acceptable results on the very first try.

● WARPING PLUG-INS

The last type of distortion plug-in is way out in left field. It takes a point or line in an image and distorts the image from that reference point. Images are zoomed in and out, bent, or duplicated to create some very unusual creative effects. Most of these plug-ins have a library of presets to get you started. The real fun though is moving the sliders and seeing the distortion effects appear in real time on the screen. There are no ideal images for this type of plug-in, so if one image doesn't work, try, try again. You'll find a variety of examples on the following two pages.

Left—Here is our colorful water lily image, which features the menu from the Plugin Galaxy Tunnel Feedback plug-in, positioned in the lower left. **Right**—The Tunnel Feedback filter has converted our water lily to resemble a spiny starfish.

Above Left and Right—Using the same Plugin Galaxy Tunnel Feedback filter, we can now cause a starfish to resemble a flower.

Top Left and Right—Using Corel's KPT Hypertiling plug-in, you can achieve some unusual effects. We took a single image of a stuffed animal, and the plug-in multiplied it on a three-dimensional plane. **Above**—A yellow wagon wheel was brought into Corel's KPT Hypertiling plug-in. A vortex feedback variation was applied to create hundreds of linked wagon wheels.

Above and Right—The Flaming Pear Flexify plug-in combines warping and mirroring capabilities to achieve some very unusual effects. **Bottom Left**—Here are what the balloons looked like before the plug-in party started. **Bottom Right**—This illustrates a basic distortion using the Web Warp from The Plugin Site. You have control over the degree you can twist the subject and how it blends into the background. The center point of the effect can be reset by right clicking on the image (in Windows).

PRINT OUTPUT

The digital darkroom allows photographers to print their own work, all in the comfort of their family room. It creates many new opportunities for you to present your final images, from scrapbooks to prints with distinctive edging. Of course, this new technology comes with its own set of problems. Not to worry, as special plug-ins are available to perform a variety of tasks and help you prepare your images for output.

Two types of plug-in are discussed in this group—practical and creative. Many of the practical application plug-ins come as part of the Photoshop installation and are automated so that you don't even realize that you are using a plug-in. On the other hand, the creative types are offered by dozens of manufacturers and mainly concentrate on edge effects.

● PROPER SIZING OF YOUR IMAGE

One of the complaints people often have with digital imaging is that the quality of printed images is lacking. Generally the problem is a mismatch of file size to printer output demands. For optimum print output, you must carefully match the resolution of the file to the size of the final print. If the original file is too small for the print size needed, your image may look

soft and can display file compression jaggies.

In Photoshop, you can resize the image using one of three resample methods. Of the three methods, Bilinear, Bicubic, or Nearest Neighbor, we have found that the Bicubic setting seems to work the best with photographic enlargements. The Nearest Neighbor option is best used for images that have very sharp lines like screen shots. The bilinear method is considered a medium-quality interpolation method that fits between the other two resample methods.

● IMAGE ENLARGEMENT PLUG-INS

If you want more options than these three resample methods offer, there

This shows a comparison of images using LizardTech Genuine Fractals Print Pro. The image on the left is an enlarged version of a low resolution file. The image on the right was increased 400 percent in size as a fractal file.

are plug-ins especially designed for increasing image size and maintaining, or even improving, image quality. We have seen two types of plug-ins that address this problem.

The first saves the image out in a new compression format such as wavelet or fractal format. You can then close your original image and open the new file format. You will be presented with a new settings menu that gives you the option of changing pixel dimensions, dpi, file size, or page size before a new image is created at the larger image size. This new image

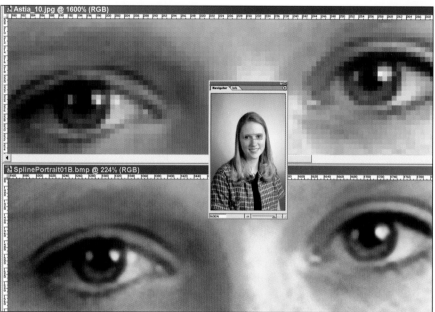

Top—The use of Extensis SmartScale is shown here. The low resolution file is on the left and the SmartScale conversion is on the right. Note that the jaggies have been greatly reduced as illustrated by the straight lines and text. **Above**—S-Spline from Shortcut Software provides another option for scaling your images. It also does a great job reducing the jaggies found in low resolution files.

ly on your editing screen. In addition, this type of plug-in gives you further options for sharpening, cropping, making edge adjustments, and controlling image detail.

● PICTURE PACKAGE IN PHOTOSHOP

On occasion, you may want to print more than one image on a single sheet of paper. Photoshop has a very nice plug-in program located in the File> Automate>Picture Package pull-down menu. When this program is activated, the image you are working on is duplicated and placed on a printing page that supports a multi-image layout. You can then change the page configuration to support two 5 x 7s, four 3½ x 5s, and other various other configurations. All the frames in the template can contain the same image, or you can select other images to fill the voids. The final print can then be displayed showing all the images together, they can be cut apart and used separately.

● MULTI-PRINTING WITH THIRD PARTY PLUG-INS

Most of the third party plug-ins take a different approach to multi-picture printing. They create special templates designed to import multiple images. These templates have masked openings with edge effects that simulate the print being torn, burned, stained, in a film strip, or any of dozens of more options.

When the plug-in menu is opened, it's easy to drop images into each masked opening. You can then size, rotate, or move each image until it

will have a reduction of the jaggies that were initially caused by either too small an original file or too high a file compression. With this new file, you can then sharpen the image before sending it for printer output. You can use either Adobe Photoshop's built-in Unsharp Mask plug-in or a

specially designed third party sharpening plug-in.

The newest type of image enlargement plug-in makes use of advanced technologies that allow the use of larger and faster computer memory. This plug-in allows you to view and resize your image in real time, direct-

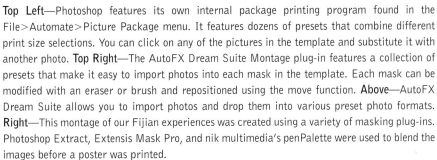

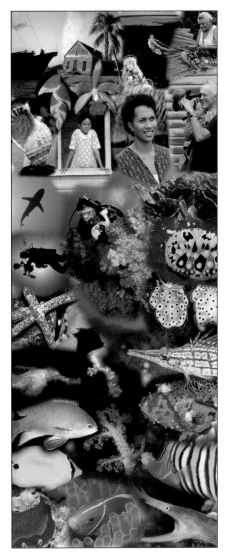

Top Left—Photoshop features its own internal package printing program found in the File>Automate>Picture Package menu. It features dozens of presets that combine different print size selections. You can click on any of the pictures in the template and substitute it with another photo. **Top Right**—The AutoFX Dream Suite Montage plug-in features a collection of presets that make it easy to import photos into each mask in the template. Each mask can be modified with an eraser or brush and repositioned using the move function. **Above**—AutoFX Dream Suite allows you to import photos and drop them into various preset photo formats. **Right**—This montage of our Fijian experiences was created using a variety of masking plug-ins. Photoshop Extract, Extensis Mask Pro, and nik multimedia's penPalette were used to blend the images before a poster was printed.

looks just right. The final result is a photo montage with enhanced edges to give a polished presentation of your images. If you want to modify any of the different masked edges, you can easily access each mask and use the Brush, Clone, or Eraser tools to modify that individual mask.

Be aware that if the plug-in you are using combines the layers during the execution process, you should add a layer before applying the plug-in. This masking layer can then be edited separately from the background image. You can even assign a specific color to that layer if you don't want to use the hues automatically assigned by the effect.

● EDGE EFFECTS

The most popular of all output plug-ins is the edge effect. This plug-in uses a special mask that blocks out portions of the image around the edges. This layer can then be adjusted using either the Layers palette or editing tools from the floating toolbox. Some of these programs are quite large and may come with several CDs of masking edge choices. Two of the largest programs we tested both had a special database system that enabled one to view different masks before applying them to the image.

Custom variations of these masks can also be made. First you select the mask layer, then use the Eraser, Brush, or Clone tool to modify the edge of the preset mask you have loaded. When you are satisfied with your newly designed mask, you can save the modified preset with a new file name. It is best to use a name that closely

This is a sample page from AutoFX showing a catalog of template pages that can be used for printing your images.

describes your new design so that you can easily locate it for future use.

Photographic edges are a variation of this plug-in that simulate the different types of film and print edges. Old-fashioned black & white prints with

serrated edges, 35mm film perforations, slide mounts, Polaroid prints, and large format film edges are all part of the photographic edge effects group. Most of these edge effects come with slider controls for texture,

Left—We selected canvas edges from the Extensis PhotoFrame catalog and applied it to this image. **Right**—The Watercolor Edge template from Extensis PhotoFrame works well for this adorable photo.

Above—The AV Bros. Page Curl allows you simulate a page turning in a scrapbook. **Right**—You can select the corner in which the curl is generated, how tight a curl, how far up it rolls, the opacity of the curl, and your choice of background image.

Above—A photograph of an eagle was imported into the AutoFX Photographic Edges plug-in, and the software automatically blended the two.

bevels, and drop shadows to provide a three-dimensional effect. Some of the more advanced templates, such as the 35mm film perforations, will allow you to add multiple images to complete the effect.

Page curls have always been a very popular effect with art directors creating magazine covers, advertisements, and posters. With this edge effect plug-in you just select the corner of the image that you want to turn, and then select a preset that adds additional three-dimensional effects to the curl. Variations to this plug-in allow you to modify the texture or surface under the curl, adjust what the curl reflects, and the degree the curl is turned up on the page.

15

FILE COMPRESSION

When digital imaging first began, file compression was necessary to conserve disk storage space and transmission times when sending files over the Internet. Today, hard disks are much larger, and prices are more affordable, so now image storage isn't as big a concern.

On the other hand, the demand for bigger images keeps growing. A few years ago a 36 MB file was considered huge. By using JPEG (Joint Photographic Electronic Group) compression, it could be reduced to 4–6 MB with very little loss of image quality. Today, because of higher printer standards, file sizes of 200–400 MB are common. The compression standard in the industry is JPEG, and although

this compression format can be used with files of this size, image editors wanted more options.

Believe it or not, the answer came to us from out of this world. Space exploration presented us with the problem that transmission of large files over millions of miles created very long download times. Standard JPEG file compression created too much loss in image quality, so two new types of file compression have appeared in the form of file format plug-ins for Adobe Photoshop.

● WEB COMPRESSION
Photoshop has its own internal file compression feature for Web images. When you select the File>Save for

Web function, you are presented with three variations plus your original file. It features some preset options that will show you different file compressions, varying file sizes, and the length of time those files will take to download. You can adjust the file type, compression ratio, or internet connection speed and type. It takes the guess work out of compressing files for use on the Web.

● FRACTAL COMPRESSION
Fractal compression plug-ins basically convert all the image data to mathematical formulas and then save the image as a new format. The new image can then be opened at a later time and rescaled to any size you

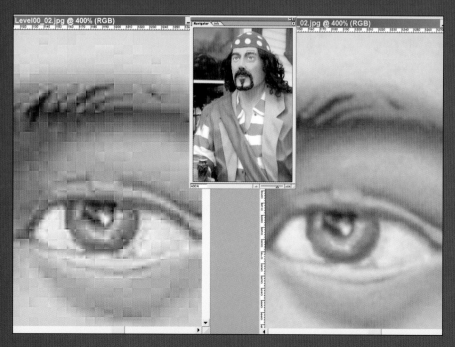

Left—This is a comparison of an image saved with different levels of compression. The image on the left has high compression (small file), and the one on the right has low compression (large file). Note that in the image on the left, extensive JPEG artifacts appear. Above—This is a typical Photoshop Save menu showing some of the more popular compression formats.

Top Left—This is the Save for Web menu found in Photoshop. The original is in the upper left, and various other compression options are displayed in the other positions. **Top Right**—This plug-in allows you to match your internet connection speed with the Web compression so you can judge image size based on download time restraints. **Bottom Left**—Another benefit of using Genuine Fractals Print Pro from LizardTech is that you can make lossless compressed files. Generally, the files sizes are reduced by as much as 50 percent when using this software. **Bottom Right**—The left image shows the photo before Genuine Fractals Print Pro has been applied, and the right image is the file reopened at a much larger size.

desire, without a loss in quality. New image sizes can be determined by percentage, pixel size, or page size. Most of the sliders in Fractal compression plug-ins will give you additional options for cropping, sharpness adjustment, and color mode changes.

● WAVELET COMPRESSION

Wavelet compression uses averages and differences of adjoining pixels at discrete levels to accomplish its compression. When the difference is close to zero, the data is thrown away, and only the averaged data is saved. This compression is usually faster than Fractal or JPEG and can embed image enhancements such as sharpening, contrast control, magnification, edge enhancements, de-noising, and error resiliency.

When you are searching for either of these plug-ins, you may not always find the words Fractal or Wavelet

appearing in the name of the plug-in. Not to worry though, because these plug-ins really do exist. The key in your search is to look at the specifications of the file format plug-ins to see just what kind of compression technique they utilize.

● NEW COMPRESSION FORMATS

Since the introduction of Fractal and Wavelet compression formats, several new JPEG plug-in formats have been added to the list of possible choices. The JPEG 2000 (.jp2 instead of .jpg extension) uses Wavelet compression that reduces the chunky effect of JPEG when files use high compression rates. The JPEG 2000 plug-in also supports lossless mode, alpha transparency, EXIF metadata, and 16-bit color modes.

Another compression format, JPEG ERI, was created by Kodak for use with their higher-end digital cam-

Top—This menu from a Kodak ERI image shows the photo has been overexposed by about two stops. The red bar at the bottom indicates that there is additional data that was captured by the camera. **Bottom**—We have now opted to include this additional data in the photo. Manual exposure control over the final image is still an option.

Photoshop now offers JPEG 2000 compression, which transfers your digital camera's EXIF information to your newly edited file.

eras. This plug-in is included with the purchase of the camera, and when the file is opened, the plug-in detects this special format. Extended highlight and shadow data is stored in a special metadata section of this new JPEG format. This data can be recalled and added to the image if more detail is needed. Essentially this new JPEG format records the exposure range that is found in RAW data formats. The resulting images have the exposure range found in color negatives.

Photoshop itself installs a large assortment of standard file format plug-ins that include both compressed and non-compressed formats. These plug-ins are necessary to ensure that Photoshop is compatible with most other file-generating programs. These include Amiga, BMP, GIF, JPG, MAC paint, PCX, PhotoCD, PCX, PIC, PNG, Pixar, RAW, TIFF, and Targa image formats.

SPECIAL APPLICATIONS

Left—Diard Software has a unique Universe plug-in that allows you to create entire solar systems, stars, novas, galaxies, and star fields. **Above**—LunarCell from Flaming Pear is a planet maker. It allows you flexible slider control over climate, air quality, cloud cover, and cities. The plug-in also has other controls so that you can adjust the light for realism.

There are literally dozens of special photographic applications that use plug-ins as part of their process. Most you will never see or hear about because they are designed for a very specific task or used in conjunction with a specific piece of equipment. Believe it or not, these special applications span from inner space to outer space—and a few spots in between.

OUTER SPACE

The fascination with outer space stems from the pictures produced by NASA and is bolstered by the ever-popular science fiction space epics. For those who would like to venture into outer space via their computer, there are plug-ins that can make it so.

The first step in creating a realistic outer space realm is to fabricate a star field. When you select this function, you can determine the brightness, density, and variations of the stars in the background. You then have the option of adding individual bright stars, nebulae, planets, and even galaxies to your image. We only found one plug-in that creates all the celestial parts, but many of the plug-ins feature individual parts such as planets, suns, and star fields. Most all of these objects can be controlled in size, brightness, and rotation.

In addition to creating outer space, you can also create a new world. One of the world creation plug-ins, LunarCell from Flaming Pear, has slider controls for clouds, air, overall climate, cities, land texture, crater control, and storm creation.

We should also note that these three-dimensional space objects can be imported into Photoshop via the three-dimensional object plug-in mentioned in chapter 6. Working back and forth with three-dimensional objects and universe plug-ins, you should be able to create just about any outer space scene you can imagine.

Above—This completed planet was made using LunarCell from Flaming Pear, and features three-dimensional landscape and atmosphere. This program allows you raise or lower ocean water level as well. **Left**—SolarCell is a companion plug-in to LunarCell from Flaming Pear. Its sole purpose is to create suns. It features all the solar effects like halos, spikes, flares, and an assortment of sun presets. **Facing Page**—One of the best filters we have found for removing digital noise from images is Dfine, from nik multimedia. We found another use for this plug-in by using it to remove astronomical background noise found in star trail photography. The line running through the top portion of the image is the International Space Station as it passed through the scene during this twenty-minute exposure.

Moving back for a minute to the real world, we found several plug-ins that can remove noise from astronomical pictures. The Dfine plug-in from nik multimedia is designed to minimize digital camera noise. Since star trails have astronomical background noise, we found this plug-in works well.

● UNDERWATER PHOTOGRAPHY

Now we move from the outer reaches of space to the depths of the sea. As underwater photographers for more than thirty years, we are constantly searching for any software tools to aid in our photographic endeavors. Underwater photography is one of the most difficult types of photography in the world with its own unique set of problems. Underwater photographers have to deal with color loss below a depth of fifteen feet, reduced shadow detail, floating particulate in the water called backscatter, dead coral sections, and much more.

Unfortunately, there are no plug-ins designed specifically for underwater photography. The good news is

Left and Above—The Digital ROC filter from Kodak is normally used to replace the color deficiencies in faded photos. We found another use for it with our underwater images. **Facing Page**—It is very difficult to capture the strobe beam of light underwater (top). Thanks to Auto FX Mystical Lighting with its LightCaster, we can now add the missing light to each flash (bottom).

that many of the plug-ins designed for general topside photography work extremely well for underwater photography. So, let's take one problem at a time and show you what plug-ins work best for each.

The loss of color underwater, especially with wide-angle images, can cause a green shift in cold water and a blue shift in warm water. The Auto Levels, Auto Color, and Auto Contrast tools in Photoshop work well for general topside photography, though with underwater images, that is not always the case. We have found that third party correction plug-ins that

support eyedroppers for white, black, neutral, and custom colors do an excellent job with underwater images. If you are still having problems with color shifts, another option is to try the plug-ins designed to restore color in faded images.

The next problem is detail loss in the shadows, which is common if images are taken at too great a distance underwater. The best solution is one of the gamma correction plug-in programs that adjusts the midtones and still maintains accurate color in the highlights and shadows. When you move the adjustment control, you will be amazed when the thumbnail image previews detail you didn't know existed.

Patches of dead coral, backscatter, and problems with sand particles can all be solved using a plug-in that fills in selected areas with data from the surrounding area. Feathering and boundary slider adjustments give you maximum image editing control.

Finally, a scratch that occurs from damaged film can be removed using one of the new scratch removal plug-ins. It works very much like the artifact removal plug-in previously discussed. The trick is to select small portions of the scratch and replace it with similar backgrounds, removing one section at a time.

● COLOR BLINDNESS

To give you an idea of how far afield the world of plug-ins has come, we found one that is specifically designed to simulate different kinds of color blindness. This plug-in is called Vis-

Above Left and Right—We have selected some detracting coral areas and have applied the Smart Fill from Alien Skin. The software looks at image areas adjacent to your selection and carefully recreates parts to make a new image. **Left**—Small particles of sand were selected using the Color Range tool and removed using the Smart Fill from Alien Skin.

Left—The Vischeck Color Deficit Simulation plug-in provides three images to simulate the most common forms of color blindness. The original full-color image is located in the upper left. **Above**—Richard Rosenman Advertising and Design has created a plug-in for generating color bars and grids for television, video, and monitor calibration and alignment.

check and simulates the three most common types of color blindness. Simply load in a photo, click on one of the types of color blindness, and the image simulates what a person would see if afflicted with that eyesight abnormality. The plug-in requires that you have a calibrated monitor, but as a good image editor, you should already know that.

◉ COLOR CHARTS

We found a couple of plug-in programs that generated various types of color charts when you load in a new blank image. One plug-in actually had choices of a video bar chart, gray scales, color scales, and several grid and alignment charts. There are no sliders in these plug-ins, just chart choices.

CREATING YOUR OWN PLUG-INS

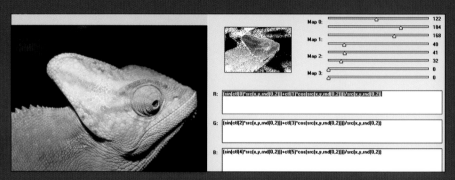

Even with the thousands and thousands of plug-in filters available, there will be those image editors who still want to create their own. One method of creating your own effects is to use one of the commercial, shareware, or freeware plug-ins, modify the settings, and save it as your own, newly created filter.

● FILTER FACTORY

Another solution is the Filter Factory. This small, custom filter program was first introduced with Photoshop 3.0 in a directory called Goodies. To find the Filter Factory plug-in in Photoshop, you will have to look in the Filter>Synthetic>Filter Factory pulldown menu. If you find that it is not installed in your computer, simply drag the FFactory directory from the Photoshop installation disk over to the plug-in folder, and it will appear after you restart Photoshop.

Once you open the Filter Factory program, it will present a simple menu with several sliders, three empty text boxes, and a thumbnail preview of your image. Your plug-in effects are created by entering mathematical formulas in each of the boxes. These arithmetic expressions will determine how each pixel in each color channel is modified to create the final effect. Simple entries will usually give simple

effects, while more complex math entries result in more complex effects. As you enter numbers into the three boxes, the thumbnail image will immediately display the effect of each mathematical entry.

Tutorials and Guides. The big advantage of the Filter Factory is that you can see both the visual effect of the plug-in and the computer language used to create the effect. To see how the system works, load in some complex effects created by someone else. This will give you a better idea of what numbers should be included in the boxes and their corresponding results. You can then modify their effect, save it out, and magically have your own new filter.

If the long line of numbers and operating gibberish doesn't scare you off, then you might also consider taking a look at the PDF tutorial and manual, which is found in the Goodies directory.

We also did a search on the Web and found the *Filter Factory Pro-*

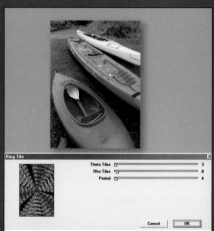

Top—Filter Factory, from Synthetic, has been a part of Photoshop's Goodies, which is found on the program's installation disk and has been available since version 3. This plugin uses mathematical formulas in the RGB boxes to create a variety of special effects. You can load in variations of these formulas from samples on the Web and modify them to create your own plug-ins. **Above**—Funhouse Ring Tile is a filter created with the Filter Factory. It uses three sliders to create image repetition in a vortex effect.

Left—Original image. **Above**—The leaf was selected using the Color Range tool, and the Filter Factory Liquid Metal filter was applied to achieve a unique look.

gramming Guide by Werner D. Streidt. This is a fifty-one-page PDF file on the Filter Factory that provides everything you want to know about creating your own filter.

Conversion. We suggest that you consider downloading many of the free Filter Factory filters off the Web.

(Stay tuned for more on Web access in chapter 21.) When you find ones you like, save them as working Photoshop plug-ins, as the Filter Factory files with *.afs extensions are not directly read as plug-ins in Photoshop (they must be converted to a Photoshop-compatible plug-in with the Make

function in the Filter Factory). Batch conversions of these *.afs files can be done in a plug-in manager, which will be discussed in further detail in chapter 19.

Another advantage of the Filter Factory is that you can also convert these plug-ins so that they can be used

in other types image editing programs, like Adobe Premiere.

◉ OTHER OPTIONS

After the introduction of the Filter Factory, a couple of new, more advanced programs have been added to the list of do-it-yourself plug-ins. Both the Filter Meister and the Filter Formula have the basic look of the Filter Factory, but with expanded menus. They feature more control over the final effect that you dream of creating. These programs have an editing feature that allows you to enter your own mathematical code or load in previously-made plug-ins and other plug-in formulas.

For the advanced plug-in editor, these programs have submenus that allow you to set the different parameters and image modes that you

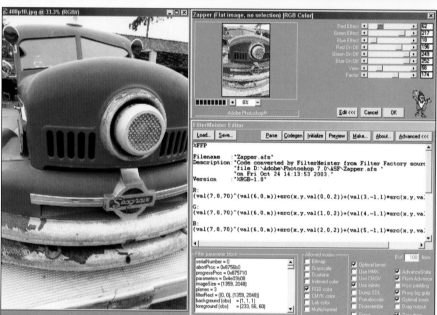

The Filter Meister editing menu has a thumbnail preview and the mathematical codes necessary to create the effect. You can load in Filter Factory source codes and modify it to create a new Filter Meister plug-in.

demand in your plug-in. Once you are satisfied with the effect you see in the thumbnail preview window, you can save the new filter in an Adobe Photoshop–compatible plug-in format. Have we confused you yet?

Above—This is a special filter created for this book by Harald Heim of The Plugin Site. It enables you to create panoramic images that blend from full color to black & white. **Top Left**—Filter Formula, from ATS Graphics, is very similar to Filter Meister and Filter Factory. It too features the mathematical codes and a preview that shows the results. You can also load in Filter Factory source codes that can be modified and saved as Filter Formula plug-ins. **Bottom Left**—Here's an image featuring the effects of the Filter Meister's ConvoLine plug-in, which simulates a solarization.

18

HARDWARE DEVICE PLUG-INS

Many of the hardware devices that are attached to computers today also take advantage of plug-ins. They use the plug-ins to create software interfaces so they can communicate directly with Photoshop. The largest group of hardware plug-ins are used with scanners and digital cameras. Not all have a plug-in, but there seems to be no rhyme or reason as to which of these do or don't include a software interface.

Many of these hardware devices will have the option of installing both stand-alone programs and a plug-in into Photoshop. Generally, you can locate these hardware plug-ins in the File>Import or File>Automate pull-down menus. Some are installed when the hardware is first attached and work quietly in the background, so you don't even know you are using a plug-in.

● SCANNERS

Both film and flatbed scanners are used to convert photographic images to digital files. The most common methods of communication with the computer are through SCSI (Small Computer System Interface), USB (Universal Serial Bus), and FireWire. Most of the scanners on the market will have either a stand-alone program or a Photoshop plug-in. The majority

feature both for controlling the hardware device.

Plug-ins created by the scanner manufacturer are quite complex. They provide you a variety of controls over both software and hardware operations of the scanner. These plug-ins give you options for adjusting color balance, exposure, contrast, gamma control, image size, and cropping.

In addition, many of the scanners, like the Nikon Coolscan, incorporate the use of special internal hardware plug-ins. The Nikon scanner incorporates Digital ICE, a group of plug-ins for dust and scratch removal, grain reduction, and color restoration.

Because of the complexity of scanners and the high quality software that's included, the need for many third party plug-in programs is reduced. Even so, a couple have surfaced, and they too feature both plug-in and stand-alone versions. Their advantage is that they interface well with multiple brand-name scanners, so one plug-in can often run two different types of scanners.

In order for these third party plug-ins to compete with the plug-in included with the scanner, they have dozens of extra features to en-hance your scanning techniques. The best part is that both the manufacturer's and third party plug-ins can be

Top—This Photoshop menu shows where you would find the various hardware plug-ins like Nikon Scan and SilverFast for scanners. **Above**—Additional hardware plug-ins can be found in the File>Automate menu. The penPalette and Dfine from nik multimedia are also located here.

installed at the same time. This allows you to move from one to the other without any compatibility issues.

The advantage of both scanner and third party plug-ins is that the scanned image is dropped directly into Photoshop for editing. When scanning one image at a time, the plug-in is still the best way to go, as you can easily scan, edit, and save the file from Photoshop.

The disadvantage is that both Photoshop and the scanner plug-in will require more memory than if the stand-alone scanner software was used. If you plan on using a special bulk feed attachment for batch scanning, we recommend that you use the stand-alone program instead. Some of

Top—Nikon makes a wide variety of scanners that feature both stand-alone and plug-in features. **Above Left**—This color negative image of a squirrel fish was severely damaged by scratching. **Above Right**—Using the internal hardware device called Digital ICE from Kodak's Austin Development Center, the scratches are magically removed during the scanning process. When purchasing a scanner, make sure it features Digital ICE.

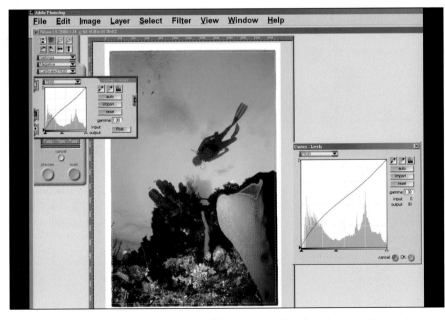 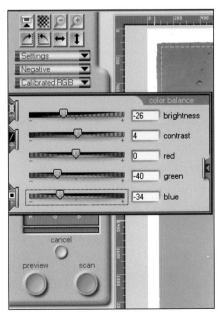

Left—This shows the Nikon Scan plug-in editing screen, which includes a preview and curve editor. **Right**—Advanced controls allow you to manually adjust the color balance, brightness, and contrast.

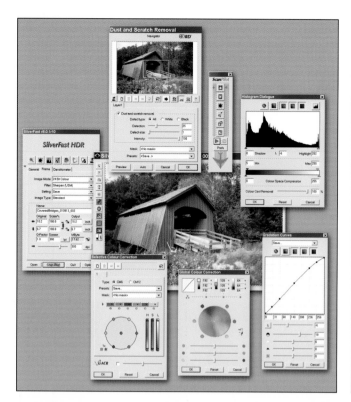

Top Left—SilverFast from LaserSoft Imaging is an advanced scanning software that features eyedroppers, densitometers, histograms, and color curves. It also includes a special dust and scratch removal feature, similar to Digital ICE, except that it is applied after the scan. **Top Right**—Card readers accept all types of storage media and are the best way to transfer data from your digital camera to your computer. **Above**—Digital camera technology is advancing at a rapid pace with new models in every shape and size being introduced.

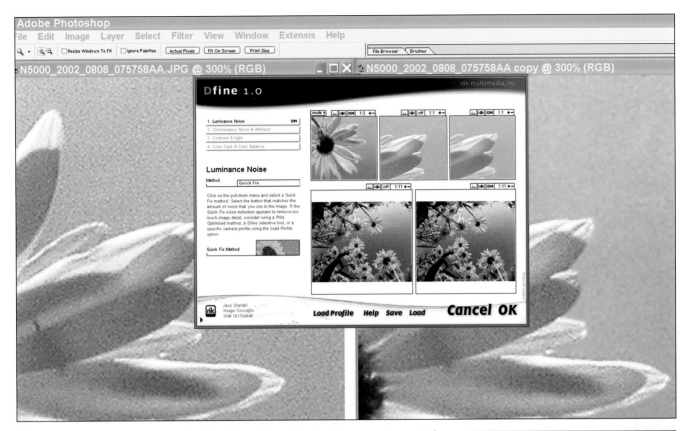

Above—This shows a camera menu in Dfine, from nik multimedia. The menu shows a before and after variation with three enlarged sections of the final image for scrutiny. **Right**—Some software manufacturers, like nik multimedia, feature plug-ins designed to work directly with specific digital camera models.

the scanner programs automatically require the use of the stand-alone program for bulk scanning, so you may not even have a choice.

⊙ DIGITAL CAMERAS

We love digital cameras and feel that they mark a new milestone for photography. You can now immediately see the results of your photographic efforts and import those charged ions into your computer. You can then view, edit, print, and archive your images.

But alas, there is strife on the digital home front. Digital cameras provide two methods for transferring images—memory cards and a communications cable. The problem is that there are some compatibility issues.

A communications cable connects from your digital camera through USB or FireWire on your computer. Each manufacturer uses a slightly different method of communication with the computer, so they each create their own special stand-alone program or plug-in software. Digital cameras each need different software to transfer their images. Quite often, the software will interfere with other computer devices that also use USB or FireWire, causing computer problems.

In most of the digital cameras we have tested, we have found both the stand-alone and plug-in software seem to cause problems more often than not. Therefore, we do not recommend the use of digital camera plug-ins. Don't even install them, as we'll

show you that there are better alternatives. The only exception would be the plug-in software that comes with high-end SLR digital cameras as it may include features that extend the camera's capabilities.

Custom Installation. Most digital cameras come with a small database image editor that allows you to make minor adjustments to your images. They enable you to rotate an image and adjust exposure, sharpness, and more. In almost all cases, you can install this software using the custom install without having to install the camera plug-in. That way you can utilize the features of the image editor

Above—For advanced image editing, the graphics tablet provides increased accuracy. Shown here is the 6 x 9-inch Wacom tablet, pen, and mouse. **Right**—This hardware plug-in comes from nik multimedia and is called the penPalette. It is designed to work with the Wacom pen and tablet.

without the enduring the headache of incompatibility.

Other Methods. Since we don't recommend the use of a plug-in for your digital camera, we should at least give you our proven method for transferring images, but it has nothing to do with plug-ins. The device is called a memory card reader. Since it must read memory cards from hundreds of different cameras, it must have fully compatible communication through either USB or FireWire. The cost is usually less than $50, and the device works much like a large capacity external floppy drive. The investment is well worth the reduced headaches and heartache of lost images.

Camera Profiles. There's a new kind of third party digital camera

Here we find several images that have been modified using Mask Pro from Extensis. The nik multimedia penPalette was used to fine-tune the masks before they were placed in the final montage.

plug-in, but it has nothing to do with how the digital images are downloaded. This plug-in's primary purpose is to reduce any negative effects due to lacking camera imaging technology and improve the quality of the image after it has been downloaded.

There are several programs out there, but one of the best we have seen is called Dfine from nik multimedia. The program installs directly in Photoshop as a plug-in and is located in the File>Automate pull-down menu. It can reduce noise, correct problems with hot pixels, fix color shifting problems, reduce JPEG jaggies, and more. The key to Dfine is that it uses separate profiles for each camera model to identify and reduce specific problems that are unique to that camera model.

● GRAPHICS TABLET

Another hardware device that commonly utilizes plug-ins is the graphics tablet. A mouse is often used to navigate around the tablet, but the most effective method is with a pen, which allows you to increase or decrease pressure as you edit. This device is often used by the more advanced and professional image editors who need to have total creative control over the editing features in Photoshop.

When the plug-in for the penPalette is opened, a special floating toolbox will appear on the screen. Depending upon which tablet system you have, you will then be able to select a tool and make very fine adjustments by varying the pressure on the pen. In most cases, the pen's plug-ins are made by a third party manufacturer and are included when you buy the hardware. We have also found that many of the higher-end commercial plug-ins have been designed to work with the mouse, pen, and tablet

19

PLUG-IN MANAGERS

If you like working with plug-in effects, you will eventually find that your plug-in directory holds more than you can manage. The list of plug-in may be so large that you must continually scroll down until you find the one that you want. You may even want to remove some filters that you don't use very often. So, how do you remove a plug-in if it's not listed as a program to uninstall, or if it doesn't have an uninstall function? The solution is a plug-in manager.

● THE PLUG-IN COMMANDER PRO

We researched a few choices on the Web, downloaded some trial versions, and then settled on the Plug-in Commander Pro for our plug-in management. (There are other plug-in managers available, of course, and you'll find them listed in the appendix.) This is a stand-alone program that works outside Photoshop. In fact, you should shut Photoshop down while you work in this plug-in directory.

Top—This is the editing screen of Plugin Commander from Harald Heim at The Plugin Site. When you double click on a filter, a small editor appears so that you can see the effect of your filter choice. Right—When you select the browser from the View pull-down menu, thumbnails of all the directories you are browsing will appear in the gallery.

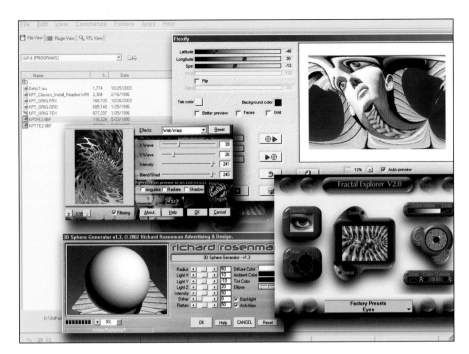

The Filter Factory editor interfaces can be changed using the preferences section of Plugin Commander.

Since Photoshop loads the locations of the plug-ins when it starts, you could make a mess of Photoshop if you start moving them around in your manager.

Plug-in managers will generally have several different methods for viewing your plug-ins. With the Plug-in Commander, you can select from file view, plug-in view, or Filter Factory view. The file view shows you where they are located on your hard disk, while the plug-in view shows you how they are presented in the Photoshop Filter pull-down menu. The Filter Factory view shows you the Filter Factory filters installed in Photoshop by name and effect.

Plug-in managers allow you to see how the plug-ins are grouped so that you can easily move them, create new groups for them, or delete them. You can also use the plug-in manager to batch convert Filter Factory files for Photoshop or Premiere file extension compatibility.

If you have other similar editing programs that have compatible plug-ins, they can be converted or copied to your Photoshop plug-in directory. You can search a specific directory or an entire hard disk for a lost plug-in. A plug-in manager is a must for anyone who wants to have optimal control over the third party tools that have been added to Photoshop.

20

PLUG-IN RESOURCES

● SEARCH ENGINE CRITERIA

The best place to begin when considering the use of plug-ins is the Web. There are several sites strictly devoted to the subject of plug-ins. When we first started to research Photoshop-compatible plug-ins, we typed "Photoshop Plug-in" and got several thousand Web page hits. It took us days to sort through them.

We were amazed at the amount of information out there. Many of the sites offered tutorials, discussion groups, plug-in resources, downloads, and reviews. Best of all, many of the dedicated plug-in pages had links to other plug-in pages. You can even sign up to receive a plug-in newsletter to keep you in tune with the latest news regarding new plug-ins.

Many of the plug-in download pages include extensive photo galleries displaying samples of each plug-in that can be downloaded. We found this very useful when narrowing down our search for specific effects in our images. Several of the plug-in Web pages are listed in the appendix along with the plug-in companies.

When assembling the appendix we found there was no surefire way to guarantee everyone was listed, as there were so many plug-ins. In addition, the plug-in market is always in a state of change, as companies buy and sell plug-ins, they are discontinued or the

Here are some of the key players in the plug-in field.

Although many of the plug-ins are acquired by download off the Internet, some companies do offer packaged CDs.

Web address changes. So, if you check one of the links in the appendix and get an error, don't despair. Just type the web page address, minus the http://www.*.com into the search engine, and you'll find plenty of pointers to direct you to the correct location.

◉ FREE AND NOT-SO-FREE PLUG-INS

Plug-in filters come in three price ranges that extend from free to about a couple hundred dollars. The free plug-in filters are usually either filters created with Filter Factory–type programs or samples by manufacturers trying to encourage you to buy their other plug-ins.

A little farther up the dollar scale, you will find plug-ins programs that you pay for, but these feature a number of effects. Other filters may be offered free of charge on a trial basis; after a given period of time you will need to register and pay for the plug-in use. The price of such filters usually starts at $5 and can go up to around $50.

The more expensive commercial plug-ins have demo programs, but they have usage limits that expire if you don't make a purchase. They also have a much broader price range depending on the capability of the filter and how many components are included. We have seen them priced as low as $29 and as high as $200.

Many editing programs such as Photoshop have a Goodies directory that includes several third party plug-ins, which are available to users on a trial basis. Since plug-ins do not take up much space on an installation CD, companies often include demo versions of all their other plug-ins for you to try.

Although upgrades are a common practice with computer software, the same does not hold true with plug-in filters. There are very few upgrades available in the plug-in market, since new filter versions usually feature something completely different from their predecessor.

◉ FINAL THOUGHTS

The world of plug-ins is an exciting one. Whether you want to enhance your editing capabilities or expand your creative skills, the plug-in can be an invaluable tool. Photographic images now have virtually limitless potential. Problem images can now be salvaged, modified, and turned into pieces of art. With just a few good plug-ins, your editing potential can be expanded farther than you've ever dreamed.

APPENDIX

COMMERCIAL PLUG-INS

Acclaim Software
http://www.focusmagic.com
Focus Magic: Corrects both out-of-focus blur and motion blur.

Adobe
http://www.adobe.com
Gallery Effects: Enhanced versions of the native Photoshop plug-ins. They aren't sold anymore as far as we know.
RAW and JPG2000: import RAW files and save as JP2 files.

AGD
http://www.plugin.artdesign.ru
Color Temperature Correction Plug-in: Correct color temperature with precision.

AGE Technologies, Inc.
http://www.agetechnologies.com/products
Clicdesign Color Chart: Manages and matches your colors.
Clicdesign Color Suite: Contains PlaidMaker v2.0, QuickRepeat, ColorVision, and StyleDraper.
ColorVision: Eliminates the need to reduce the number of colors when recoloring fabrics.
PlaidMaker, PlaidMaker Pro: Yarn dye fabric design systems.
QuickRepeat: Textile designers can easily repeat images.
StyleDraper, StyleDraper Pro: Create an infinite range of samples.

ALAP—a lowly apprentice production, inc.
http://www.alap.com/products/pm.html
PlateMaker: Saves each channel as an individual separation plate with a DCS 2.0 file.

Algo Vision
http://www.algovisionluratech.com/products/lurawave/photoshop
LuraWave: Reads and writes LuraWave compressed images.

Alien Skin Software
http://www.alienskin.com
Eye Candy 4000: Twenty-three filters to fortify any user's creativity. Includes bevels, glows, fire, chrome.
Image Doctor: Four powerful image-correction and repair filters.
Splat!: Six filters combine frames, textures, edges, borders, mosaics, and more.
Xenofex: Fourteen filters to simulate spectacular natural phenomena.

AliveColors
http://www.alivecolors.com
AliveColors: Eight different color correction effects, both stand-alone and plug-in.

Andromeda Software, Inc.
http://www.andromeda.com
Cutline: Four screens for exceptional hand-engraved and woodcut effects. Stamp directional screens.
EtchTone: Simulates the look of a steel etching.
LensDoc: A universal solution to lens distortions.
Measurement: For medical, scientific, or graphic arts image analysis.
Perspective: Provides 360-degree image rotation for perspective distortions.
Photography Filters: Collection of ten filters that let you

add special optical lens effects to your images quickly and easily.

RedEye Pro: A direct and easy method of red-eye removal.

ScatterLight: Produces patterned and diffusion lens effects.

Screens: Converts grayscale into a wide variety of different line-art screens.

Shadow: Features real three-dimensional shadowing.

Techtures: Five hundred hand-rendered realistic textures.

Three-D, Three-D Luxe: Offers true three-dimensional surface wrapping, viewpoint control, image and surface manipulation, and shading.

VariFocus: Lets you focus/defocus features in your image with custom control.

Velociraptor: Create stylized motion trails.

Antelligent MicroSystems

http://www.antelligent.com/pages/ps_plugins.html

Color Darkroom: Allows you to edit and fine-tune your printer's color profiles.

ApEL Software

http://www.bitmix.cz/defaultEN.htm

biTmiX: Used for creating impressive signs, reflections, and other decorations in metal and rough, non-flat surfaces.

Mr. Smith: Designed for creation of plastic effects with gloss, shade, and color transition.

Applied Science Fiction; See Kodak's Austin Development Center

Asiva

http://www.asiva.com/plug-ins.html

Correct+Apply Color: Accurate ways to change the color in your images.

Sharpen+Soften: Gives the user control over sharpening or softening image areas.

Shift+Gain: Make nearly seamless selections and adjust hue, saturation, and color values.

ATS Graphics

http://www.ats-vienna.com/graphics

Filter Formula: Allows you to create your own filters using a simple language which is very similar to C.

Auto FX Software

http://www.autofx.com

AutoEye 2.0: Rebuilds lost detail and color in images.

DreamSuite Gel Series: Create vibrant and translucent colored artwork and images.

DreamSuite Series One: Eighteen visual design solutions for type, graphics, and photographs.

DreamSuite Series Two: Twelve new plug-in creative options.

Mystical Lighting: Apply sixteen photo-realistic lighting and shading effects to images.

Mystical Tint, Tone, and Color: Thirty-eight tonal editing effects to creatively enhance images.

Photo/Graphic Edges: Fourteen photographic effects to give images unique shape and dimension.

AV Bros.

http://www.avbros.com

PageCurl: Realistic and high quality turning-page effects.

Puzzle Pro: Allows powerful freedom in the creation of puzzle-shape effects.

Axion Software

http://www.axionfx.com

Flare Effects: Create a wide variety of lens flares, sparkles, and other wild effects.

Glow and Sparkle: Create a wide variety of glows, sparkles, and other effects.

Bengt Computer Graphics

http://www.importeps.com/html/products.html

Import EPS: Enables users to import Postscript or PDF pages into Photoshop.

Box Top Software, Inc.

http://www.boxtopsoft.com

ColorSafe: Provides fully interactive color pickers for limitless hybrid colors.

ImageVice: Powerful color reduction tool that can also be used to gain better image compression.

PhotoGIF: Tool for making better Web graphics.

ProJPEG: JPEG tool for Web graphics professionals.

Camera Bits, Inc.

http://www.camerabits.com

Band Aide for the Nikon D1: Specifically for reducing the "pitting" or "banding" noise from high ISO Nikon D1 photos.

Quantum Mechanics: For removing color noise and artifacts from digital camera images and film scans.

CGSD

http://www.cgsd.com/texture/tools.html

Real Texture Tools: Designed to assist digital artists in the creation of realistic texture patterns.

ChromaSoftware

http://www.chromasoftware.com

Highlight Control: Extracts detail from the highlights.

IR Film: Emulates the look of infrared film or a photo taken using an infrared filter.

Photographic Filters: Works just like having unlimited amount of filters in your camera bag.

Shadow Control: Boost details in otherwise lost, dark areas of deep shadow in the image while preserving details in highlights.

Smart Sharpen: Sharpening tool that works on the edges, while leaving the featureless areas intact.

Colorfield Software

http://www.colorfield.com/insight

Insight: Allows designers to predict image legibility for color deficient viewers by accurately simulating color blindness.

Corel

http://www.corel.com/servlet/Satellite?pagename=Corel/Products/AllProducts

KnockOut: Complex masking solution with absolute precision.

KPT Collection: The best of Kai's Power Tools plug-in

filters with remarkable image transformations and original effects.

Creo, Inc.

http://www.creo.com

Powertone: Generates colorful images that can be printed with only two inks.

CyberView Corporation

http://www.cyberviewcd.com/cvimage/index.html

Image: Advanced, interactive JPEG image compressor.

Diaquest

http://www.diaquest.com

Digital Disk Recorder: Provides a simple and direct means to import and export extremely high quality digital video.

Diard Software

http://www.diardsoftware.com

Universe Image Creator: Create realistic images of space including stars, nebulae, galaxies, and more.

DigiEffects

http://www.digieffects.com

Euphoria: Includes twenty effects like AgedFilm, old-movie effects, StarField, and FogBank.

Digital Element

http://www.digi-element.com/site/index.htm

Aurora: Provides true digital nature effects within Photoshop.

Modelshop: Provides instant access to thousands of models.

Verdant: Allows users to randomize, rotate, scale, and place plants and trees.

Digital Film Tools

http://www.digitalfilmtools.com/html/products_main.html

Composite Suite: Contains twenty-eight visual effects.

Digital Film Lab: Meant to simulate a variety of film looks, filters, lenses, and processes.

55 mm: Meant to simulate popular glass camera filters.

Light!: Adds light to the scene.

Ozone: Manipulate the color of an image with incredible flexibility and accuracy.

DVP Technologies

http://www.dvp.co.il

EyeFidelity Tools: Specialized retouching solutions for professionals using digital cameras, scanners, and printers.

Extensis

http://www.extensis.com

Intellihance Pro: Fast and easy image enhancement.

Mask Pro: Unmatched masking power and precision.

PhotoFrame: Endless border effects in Photoshop.

PhotoTools: Special effect tools for Photoshop.

SmartScale: Creates high quality scaled images by preserving the color and brightness data contained in the original image.

Fantastic Machines

http://www.fantasticmachines.com/html/filters.htm

FM Tile Tools: Twenty-one filters designed for creating tileable images and textures.

FixerLabs

http://www.fixerlabs.com

FocusFixer: Removes focus blur and sharpens conventional photography.

NoiseFixer: Designed to remove "noise" or "graininess" from images.

ShadowFixer: Correct the problem of different exposure requirements within one image.

Flaming Pear Software

http://www.flamingpear.com

Creative Pack: Furbo filters with winding edges, undulating surfaces, bright colors, and patterns.

Designer Sextet: Six plug-in filters to warp, recolor, abuse, and dreamify your images.

Flexify: Bend spherical panoramas into vertiginous new shapes.

Flood: Flood control with pseudo–three-dimensional watery reflections, waves, and ripples that appear realistic.

Glitterato: Stars and nebulae with lots of realism and little fuss.

Hue and Cry: Create abstract regions of color and endless weird imagery.

India Ink: Convert color images to unusual black & white halftones.

Knot: Twisted three-dimensional abstractions.

LunarCell: Instant planets featuring fractal, reality-based, or just strange worlds.

Melancholytron: Make pictures moody, nostalgic, and somehow sad.

Mr. Contrast: Add dramatic contrast to photos.

SolarCell: Design your own sun with controls for every part of its appearance.

Super BladePro: Surface and texture generator.

Tesellation: Turn any graphic into a seamlessly repeating tile.

Webmaster Series: Furbo filters for controlling color for web imagery.

Fo2PIX

http://www.fo2pix.com/index.php

BuZZ Pro: Removes unwanted detail from an image and turns it into a work of art.

Frischluft

http://www.frischluft.com

flAIR: Eight fast, high quality filters.

Lenscare: Depth of field and out of focus effect generation.

Furbo Filters; *See* Flaming Pear Software

Gamut Imaging

http://www.gamutimaging.com

ImageBook: Creates proof sheets consisting of thumbnail images in any size and style.

Geomantics

http://www.geomantics.com/fabric.html

FabricWeaver: Generate thousands of different woven fabrics in photorealistic detail.

GraphicXtras (previously Sapphire Innovations)

http://www.graphicxtras.com

Andrew's Plugin Collection: Thirteen volumes of powerful unique color effects with 290 plug-ins.

Filters Vol. 1–70: Filter Factory plug-ins in a wide range of weird and wonderful styles.

PluginMagic: Contains over 1200 plug-ins.

Hot Door

http://www.hotdoor.com

Harmony: Helps you choose the perfect colors for stunning print and Web design.

Vertigo HotText: Create three-dimensional text along custom paths.

Human Software

http://www.humansoftware.com

AutoCorrect: Reclaim lost colors and details in photos.

AutoFocus: Denoise, deblur, and sharpening tools.

AutoMask: Automatic multi-density masking.

AutoSelect: RGB color changes without masking.

CD-Q: Produce ready-to-print color separations from all your Photo CD pictures.

ClassicFrames: Tool to add the final classy touch to your images.

MagicFrames: More than four hundred ready made edges for all your images.

MagicTrack: 250+ ready-made effects and a powerful drawing application.

OttoPaths: Create and manipulate outline text within Photoshop.

PhotoFixlens: Allows you to correct all kinds of wide-angle distortions.

PhotoLight: Generate photographic lighting effects.

PhotoPatch: Two hundred ready made Patchwork/Weave/Mosaic effects.

PhotoSpray: Brush with natural images.

PhotoSurface: Contains 110 ready made textures or surfaces.

PhotoWeave: Create all kinds of plaids, striped fabrics, or patterns.

SelectPro: Perform accurate, very smooth color corrections without creating a mask.

SmartPicker: Color wheel designed to help you pick the right colors for your designs.

SpiroMaker: Easily create Spirograph-type designs.

Squizz: Used to create all kinds of distortions.

StarMaker: Create stars and starbursts as paths, selections, or layers.

Textissimo: Offers 750 text effects.

XFile: Efficient upsizing algorithms for very important image enlargements.

I C Net Software

http://www.icnet.de

Filters Unlimited: A filter development system with 350 built-in filters.

Photo Aging Kit: Let your photos look a hundred years old.

Plugin Manger: A unique tool for managing plug-ins of Adobe Photoshop.

ImageAlign

http://www.imagealign.com/demo.asp

Grasshopper's ImageAlign: Corrects both camera tilt and lens curvature.

Image Content Technology

http://www.lucisart.com

Lucis Art: Corrects scans and repairs improperly exposed images, enhances image detail, and provides creative image control.

ImageXpress

http://www.ixsoftware.com

Alius: Takes posterization to a whole new level.

AutoPilot: Automatically turns that raw image into professional quality artwork.

Deep Bit Filters: Lets you work on 16-bit images.

ScanPrepPro: Automates Photoshop's tools to produce top quality color separations, halftones, and line art.

Imagiam

http://www.imagiam.com/pages/english/main.htm

Lenticular Effects: Master flipping, zooming, animation, morphing, rotations, and three-dimensional effects.

MaskWarrior: Automatic generation of masks and paths.

PathOptimizer: Converts a mask into an optimized path.

theimagingfactory
http://www.theimagingfactory.com

Chromex I: Selectively change an entire color to a completely different one.

Color Correction: Original selective color correction in RGB, CMYK, and Lab.

Color Equalizer: Change saturation and brightness at different color hues.

Convert to B&W: Tool for customized color-to-black & white conversion.

Debarrelizer: Corrects barrel distortion and chromatic aberration as well.

Gaussian Blur: Precision Gaussian blur, including anti-aliasing actions.

Graduated Color: Digital equivalent of millions of graduated color filters.

Graduated Fog: Digital equivalent of a graduated mist filter.

Noise Reduction: Tackle any type of digital noise— luminance and color noise control.

Perspective: Corrects perspective distortion while providing live visual feedback.

Simulated DOF: Enhance the perception of depth in pictures.

Soft-Focus: Add a "romantic glow" and disguise unwanted detail.

Squeeze: Subjects at the edges of group photos become "larger than life." Use this tool to squeeze them back to normal proportions.

Unsharp Mask: Leave skin tones smooth, while sharpening other colors.

Vignette: Removes lens and telescope vignetting defects or uneven flash patterns.

White Balance: Convert the color temperature easily.

White Point: Adjust white balance while selectively retaining the original color cast.

INFINITimages
http://www.infinitimages.com

FotoPage: Create high quality digital and printable contact sheets.

Kekus Digital
http://www.kekus.com

Panotools: Series of five tools, including: LensFix, for fixing lens imperfections; Correct, for correcting image distortions; Remap, which converts files between image projection types; Adjust, a method for creating or extracting panoramas; and Perspective, which is used to change the orientation of an image.

Kodak
http://www.kodak.com or
http://www.kodak.com/cgibin/webCatalog.pl?
product=KODAK+Photo+CD+Acquire+Module

Photo CD Acquire Module: Lets you select, customize, and import Photo CD images.

Kodak's Austin Development Center (formerly Applied Science Fiction)
http://www.asf.com

Digital GEM: Reduces noise and grain.

Digital ROC: Automatically restores color to faded images.

Digital SHO: Reveal hidden details in highlight areas as well as shadow areas.

Kuvic
http://www.centralnet.hu/kuvik/angol.htm

Kuvic Filters: Thirteen enhancement and special effects plug-ins.

Laser Soft Imaging
http://www.silverfast.com

SilverFast: Control for desktop scanners and digital cameras.

LizardTech, Inc.
http://www.lizardtech.com

Genuine Fractals: Create resolution-independent images from any size file and print superior quality enlargements without any image quality degradation.

Lokas Software

http://www.artistic-effects.com

Artistic Effects: Filters that make up professional computer artist toolboxes.

3D Maker: Allows creation of pseudo three-dimensional graphics elements out of two-dimensional drawings.

MatchLight, Inc.

http://www.gomatchlight.com

Digital Photography ToolKit: Create realistic image composites with MatchLightV3, QuickComp, Light-Targets, and SmartImages.

Metacreations; *See* Corel Corporation

MicroFrontier

http://www.microfrontier.com

Pattern Workshop: Create and edit patterns and use them to fill a selection.

Microsoft

http://www.microsoft.com

Impressionist: For creating impressive brush effects. Bundled with Image Composer in Frontpage 2000.

namesuppressed design

http://www.namesuppressed.com/design

Autochromatic: Creates colorized, grayscale, duotone, and tritone style images.

Autointerlace: Automatically creates the interlace effect you see on television screens.

Softener: Add soft, glossy effects to your images.

New Virtual Research

http://www.newvirtualresearch.com

BorderMania: Create a variety of basic borders around images or Web buttons.

PhotoSwizzle: Continues boldly into new territory beyond BorderMania.

nik multimedia, Inc.

http://www.nikmultimedia.com

Dfine: Allows you to reduce noise while balancing image details, color, and light.

Color Efex: Fifty-five filters for enhancing or stylizing any photo.

Sharpener: Tool for sharpening images of any size for any output process.

penPalette: Allows you to apply filters selectively to any image.

Nova Design, Inc./Digital Dominion

http://www.novadesign.com

Cinematte: For blue and green screen compositing techniques.

Panopticum

http://www.panopticum.com

Alpha Strip: A unique set of procedures for cutting the images on alpha channel.

Digitalizer: Image can be represented by a matrix; the elements will then form the shape of the initial image.

Engraver: Cuts through images using thin lines to form a geometric pattern as if engraving.

Fire: Realistic fire effects.

Lens Pro: Design realistic lenses and three-dimensional crystals as well as crystalline three-dimensional models.

Photo FX 2.0: Big effects collection.

Plugin Galaxy: Set of twenty plug-ins with over 120 effects.

PCDip

http://www.gluonics.com/pcdip

PCDIP: Creates indexes for Photo CDs.

Pegasus Imaging Corporation

http://www.pegasusimaging.com

ImagePress JPEG2000: Compresses images to 100 percent–compatible JPEG 2000 format.

JPEG Wizard: Create smaller, faster-downloading images without compromising quality.

PhotoTune Software

http://www.phototune.com

20/20 Color MD: A photo correction wizard.

Photron USA

http://www.photron.com

Primatte: Ultraprecision matte-control blue-screen compositing.

Pixel Genius

http://www.pixelgenius.com/products.html

PhotoKit: Accurate digital replications of common analog photographic effects.

PhotoKit Sharpener: Provides a complete "sharpening workflow."

Pixel Post Studio

http://www.toolsfortelevision.com

Tools for Television Photoshop Toolbox: An aresnal of video tools for Photoshop.

The Plugin Site

http://thepluginsite.com

ColorWasher: PhotoWiz filter corrects color, contrast, and the exposure of photos.

FocalBlade: PhotoWiz plug-in for sharpening photos for screen display and print.

HyperTyle: Generates texture, surface, paint, erosion, transparency, edge, frame, and shadow effects.

PhotoWiz: A series of plugins for correcting, enhancing, restoring, and editing photos.

Plugin Galaxy: Twenty-one filter plug-ins with 159 basic effects.

Power Retouche

http://www.powerretouche.com

Power Retouche: Complete package of photo editing and photo restoration plug-ins.

Rayflect; See Corel

Redfield Plugins

http://www.redfieldplugins.com

Jama 2000: Flexible deformation tool and eccentric pattern/texture generator.

Lattice XP: Extremely powerful three-dimensional structure maker.

Ripples Magic: Powerful tool for creation of composite three-dimensional surfaces.

Texturation 3D: Multilayer texture mapper.

Reindeer Graphics, Inc.

http://reindeergraphics.com

Fovea Pro: Set of functions for the computer-based image processing and measurement of images.

The Image Processing Tool Kit: Lower-cost set of tools that include most of the functions of Fovea Pro.

Optipix: Suite of plug-ins for enhancing digital photographs.

Right Hemisphere

http://www.righthemisphere.com/products/dpaint

Deep Paint: Amazingly realistic three-dimensional paint effects; works as stand alone or plug-in.

RKD

http://knm.homeip.net:8081/Public/Photoshop%20Tools

SmarterAR: Removes artifacts and enhances detail in digital camera images.

SmarterNR: Removes noise and grain from images.

SmarterResize: Resize an image without regard to its portrait or landscape orientation.

SmarterSharpen: Sharpens an image based on its output resolution.

SmarterSharpenX: Ultimate edge-sharpening tool.

Second Glance Software

http://www.secondglance.com

Chromassage: Color table manipulation and palette rotation.

PhotoCell: Designed to convert Photoshop layers into animation files.

PhotoSpot: Creates continuous tone separations using spot-color inks.

ScanTastic: Scan directly into Adobe Photoshop or onto your desktop.

SilverOxide

http://www.silveroxide.com

Black and White: Return your colorized images to black

& white, 8 bit and 16 bit versions.

Sepia Toning: Provides the old-time look of toning in sepia and other colors.

Silver IR: Emulate the look of infrared images.

SiteJazz Corporation

http://www.sitejazz.com

smartGIF: Lets you divide a single Photoshop file into multiple Web-ready GIFs.

SkyPaint

http://www.skypaint.com

SkyPaint: Paint tool for creating and editing three-dimensional, seamless, 360-degree panoramic images.

The Software Construction Company

http://www.swcc.com/sccpik.html

SCC Plug-In Kit: Support for JPEG, TIFF, and IPTC file formats.

Spaceward Graphics

http://www.satoripaint.com

Satori Paint FX: Real-time 64-bit vector paint effects.

Stoik Imaging

http://www.stoik.com

PM ArtGallery: Will make your picture look oil-painted, engraved, or hand-drawn.

PM Rubber: A collection of outstanding plasticity and deformation filters

Sur-Reality Graphics

http://www.sur.irkutsk.ru

Distort: Curve-line gradient algorithm that uses paths like shape lines.

Tech Pool Software

http://www.techpool.com

Transverter PI: Brings PostScript rasterizing to Photoshop.

toolfarm.com

http://store.yahoo.com/toolfarm/3806.html

Grain Surgery: Noise manipulation tools for film and digital images.

Total Integration, Inc.

http://www.totalint.com

HandShake/LW: Reads and writes files in Handshake linework (LW) format.

IRIS CT: Acquires and exports IRIS CMYK Front-End Processor (FEP) image files.

Two Pilots

http://www.colorpilot.com/plugin.html

Color Pilot: Designed for the quick and easy color correction of images.

Ulead

http://www.ulead.com/download/freedownload.htm

Ulead GIF-X Plugin: Twenty-two high-end light and motion effects.

Ultra-Sharpen

http://www.ultrasharpen.com

Ultra-Sharpen: A powerful, flexible and easy-to-use sharpening plug-in.

Van Der Lee

http://www.v-d-l.com/adrenaline.html

Adrenaline: The name of a series of Photoshop-compatible plug-ins that include: OldMovie, which allows you to transform digitized images into photographs and films of the old days; and Halftone, a plug-in that allows you to apply perfect-quality halftone dithering to any image.

Vertigo 3D Software

http://www.vertigo3d.com

HotTEXT: Create real three-dimensional text right inside Photoshop.

QuickSpace: This is the little brother to 3D Dizzy.

3D Dizzy: Work with real three-dimensional models and select camera angles and lighting effects.

VIMAS Technologies

http://www.vimas.com

Web Image Guru: Superior web graphics optimizing
package.

Web JPEG: Superior JPEG compression and thumbnail
generation.

Vivid Details; *See* PhotoTune Software

Vizros Software, Inc.

http://www.vizros.com

Vizros Plug-ins: Make realistic, high quality, sophisticated
three-dimensional page-wrapping effects.

Xaos Tools, Inc.

http://www.xaostools.com

Paint Alchemy: The amazing "brushing engine" filter.

Segmation: Converts photos into contours and patterns
instantly.

Terrazzo: A seamless tile generator filter.

Total Xaos: Bundle of Paint Alchemy, Terrazzo, and
TypeCaster.

TypeCaster: A three-dimensional type filter.

FREE AND ALMOST FREE

There are more than 5,500 Photoshop-compatible plug-ins
that are free or almost free. We can't list all their products,
but we have made an effort to list the companies and their
web sites to aid your research. Some of these programs are
free, others are trial versions, require a small donation, or
are offered for a minimal charge. Many of these companies
also offer software for commercial sales.

Adobe

http://www.adobe.com/support/downloads

AFH

http://www.afh.com/web/pshop/free.html

Alf's

http://planeta.terra.com.br/informatica/pluginhead

Alien Skin

http://www.macromedia.com/downloads

AliveColors

http://www.alivecolors.com

Almathera Systems

http://www.mways.co.uk/prog/plugin.php

Amphisoft

http://photoshop.msk.ru/as/index.html

Andrew's Filters

http://stevesdesktopphotography.com/plugins.htm

Andromeda

http://www.andromeda.com

AppliedScience Fiction; See Kodak's Austin
Development Center

Timo Autiokari

http://www.aim-dtp.net/aim/plug-ins/fifo/index.htm

AutoFX

http://www.autofx.com/freeplugins

AV Bros.

http://www.avbros.com

Axion

http://www.axionfx.com

Sandy Blair

http://www.psptips.com/filters02.html

BoxTop Software

http://www.boxtopsoft.com

Boxwork Corporation

http://www.boxwork.com/gammawork/index.html

Andrew Buckle
http://www.photoshop-filters.com

ChromaSoftware
http://www.chromasoftware.com

Chyron
http://www.chyron.com

Joe Cilinceon
http://www.dizteq.com/joestuff/freestuff.html

Club Photo
http://www.clubphoto.com

Colleen's Photoshop Plugins
http://pw1.netcom.com/%7Ekawahara/photoshop.html

CoolType; *See* Electric Image

Corel
http://www.corel.com/servlet/Satellite?pagename=Corel/Products/AllProducts

CPK Design
http://hem1.passagen.se/grafoman/plugtool/plugs.html#cpk

Dennis Crombie
http://bmath.net/dc

CyberView
http://www.cyberviewcd.com

Cybia Labs
http://www.cybia.co.uk/plugins.htm

Kevin Daniel
http://www.freephotoshop.com/html/kevin_daniel.html

Berthold Daum
http://www.freephotoshop.com/html/berthold_daum.html

DC Filters
http://www.bmath.net/dc/index.html

Paul Dempsey
http://www.dcnicholls.com/plugins

Helmut Dersch
http://www.fh-furtwangen.de/~dersch

Diard Software
http://www.diardsoftware.com

DigiEffects
http://www.digieffects.com

Digimark
http://www.digimarc.com/imaging/plugin.htm

Digital Element
http://www.digi-element.com/site/index.html

DigitalFilmTools
http://www.digitalfilmtools.com/html/products_main.html

DragonFly
http://www.Philipp-Spoeth.de

DVP Technologies
http://www.dvp.co.il

Electric Image
http://www.electricimage.com

Enki
http://www.netreach.net/~barry/downloads.html

Eric
http://www.gormly.com/ericsfx

ER Mapper
http://www.ermapper.com/online/software/plugin/photoshop

Etsuro Endo
http://www.edesign.com/filters

Extensis
http://www.extensis.com/download/index.cgi/Freeware

Fantastic Machines
http://www.fantasticmachines.com

Brian Fernandes
http://photoshopplugins.tripod.com

Filter Factory
http://mitglied.lycos.de/filterfactory

Filter Farm
http://www.kees.cc/ffarm/ffarm.html

Filter Formula
http://www.ats-vienna.com/graphics/exampl.htm

FilterMeister
http://www.filtermeister.com

FixerLabs
http://www.fixerlabs.com

Flaming Pear
http://www.flamingpear.com/download.html

fnord Software
http://www.fnordware.com

Focus Magic
http://www.focusmagic.com

French Touch
http://www.pol-online.net/web-archives/french-touch/products

Frischluft
http://www.frischluft.com

FunHouse
http://hem.passagen.se/grafoman/plugtool/plugs.html#funhouse

Geomantics
http://www.geomantics.com/fabric.html

Renaud Gombert
http://www.geocities.com/SiliconValley/Monitor/4456/plugins.html

Graphics Plus
http://www.photoshop-filters.com/html/the_filters.htm

GraphicXtras
http://www.graphicxtras.com/updates.htm

Greg's Factory Output
http://hem.passagen.se/grafoman/plugtool/plugs.html

The Groan Zone
http://groan-zone.net/index.html

Happy Monkey
http://www.geocities.com/SiliconValley/Monitor/4456/plug-ins.html

Harry's Filters
http://thepluginsite.com/products/harrysfilters/index.htm

Human Software
http://www.humansoftware.com

Icabod
http://www.photoshop-filters.com

I C Net
http://www.icnet.de

ImageDrome
http://www.imagedrome.com/products.html

Imaging Factory
http://www.theimagingfactory.com

Infinitimages
http://www.infinitimages.com

JASC
http://www.jasc.com

Jinte
http://www.jintek.com/type_cham.html

Michael Johanhannwahr
http://www.johannsworld.de

Kangaroo
http://www.photoshop-filters.com/html/kang.htm

Kiwi
http://www.freephotoshop.com/html/kiwi.html

Mario Klingemann
http://www.photoshop-filters.com/html/the_filters.htm

**Kodak Austin Development Center
(Applied Science Fiction)**
http://www.asf.com

Körber and Chronz
http://webuser.rheinmain.net/grafcolor/html/rgbtogra.htm

Krusty
http://www.krust.com

John E. Laroche
http://www.freephotoshop.com/html/john_e._laroche.html

Licentia
http://www.licentia.fi/english

Linkware Graphics
http://www.linkwaregraphics.com/presets/index.html

Tim Lister
http://members.ozemail.com.au/~tal/Filters

LizardTech
http://www.lizardtech.com

Lokas Software
http://www.artistic-effects.com

LucisArt
http://www.lucasart.com

Lumis
http://www.highend3d.com

Magic Software
http://www.magicsoftware.com

Mark's Plugins
http://www.pspug.org/filters/filtersff.shtml

Alfredo Mateus
http://www.freephotoshop.com/html/alfredo_mateus.html

Kipp Mc Michael
http://www.photoshop-filters.com/html/funhouse.htm

MediaChance
http://www.mediachance.com

Media Spark
http://www.mediaspark.com/index.html

Steve Mockensturm
http://www.photoshop-filters.com/html/mocks.htm

MuRa's Filter Meister
http://www.geocities.com/murakuma/mmplugins.html

NameSuppressed
http://www.namesuppressed.com/design

Neu
http://www.btinternet.com/~cateran/neu

NewVirtualResearch
http://www.pluginfilters.com/index.html

nik multimedia
http://www.nikmultimedia.com

nvidia
http://developer.nvidia.com/object/nv_texture_tools.html

Oliver
http://www.originalversion.net

Balder Olrik
http://www.the-void.dk/filters/filter.htm

Olympus
*http://www.olympusamerica.com/cpg_section/
cpg_downloads.asp*

Leos Ondra
http://leo.astronomy.cz/grlens/grl0.html

Panopticum
http://www.panopticum.com

Pantone
http://www.pantone.com

Gregory Paret
http://www.users.cloud9.net/%7Egparet/photoshop

Lindon Parker
http://www.freephotoshop.com/html/lindon_parker.html

Paurex
http://www.paurex.com

Pegasus Imaging
http://www.pegasusimaging.com

PhotoSynthesis, Inc.
http://www.panix.com/~jnr

Pixel Genius
http://www.pixelgenius.com/products.html

The Plugin Site
http://www.thepluginsite.com

PNG
http://www.freephotoshop.com/html/png.html

Print Image Matching
http://www.printimagematching.com

Kees van Prooijen
http://www.kees.cc/ffarm/ffarm.html

Power Retouche
http://www.powerretouche.com

Roberto Puon
*http://home.hiwaay.net/%7Epuon/photoshop/
buttonMaker.html*

Redfield Plugins
http://www.redfieldplugins.com

Red Prince
http://www.redprince.net/atelier

Reindeer Graphics
http://www.reindeergraphics.com/free.shtml

RGB - 2 - Gray
*http://webuser.rhein-main.net/grafcolor/html/
rgbtogra.htm*

Rich FX
http://download.richfx.com/zoomfx/ZoomFXPro_3_2_01.zip

Right Hemisphere
http://www.righthemisphere.com/products/dpaint

RKD
http://knm.homeip.net:8081/Public/Photoshop%20Tools

Rorshack
http://www.freephotoshop.com/html/rorshack.html

Richard Rosenman
http://www.richardrosenman.com/photoshop.htm

Francois Saluden
http://www.saluden.com

Jagannathan Sampath
http://members.tripod.com/sjagannathan/index.htm

Tatsuya Sasaki
http://www.kt.rim.or.jp/~takinami

Greg Schormo
http://www.state-of-entropy.com

Scribe
http://www.freephotoshop.com/html/scribe.html

Simple
http://www.btinternet.com/~cateran/simple

Stereopsis
http://www.stereopsis.com/fresnel

Stoik Imaging
http://www.stoik.com

Werner D. Streidt; *See* Filter Factory

Telegraphics
http://www.telegraphics.com.au/sw

Teph's Tricks
http://psp.tephras.com/filters/index.html

Tin Shed Observatory
http://astroshed.com/fitsplug/fitsplug.htm

Toadies
http://photoshop.msk.ru

Trond
http://come.to/tronds

TV Effects
http://www.togls.com/tvfilter.html

Two Moon
http://daaroot.com/FluttrbyDesigns/PSPTuts/Vibes/
MetallicVibrations.html

Two Pilots
http://www.colorpilot.com

Ulead
http://www.ulead.com/download/freedownload.htm

Unplugged
http://www.v-d-l.com

VanDerLee
http://www.v-d-l.com/plugins.html

Vertigo 3D
http://www.vertigo3d.com

Vischeck
http://www.vischeck.com/vischeck

Vizros
http://www.vizros.com

Wacom
http://www.wacom-europe.com/uk/downloads/tools/tools.asp

Xaos Tools
http://www.xaostools.com

Xero Graphics
http://www.xero-graphics.co.uk

Xynthetic

http://www.geocities.com/SiliconValley/Bridge/7631/
webscrub.zip

PLUG-IN MANAGERS

I C Net

http://www.icnet.de

Plugin Manager: Unique tool for managing plug-ins for
Adobe Photoshop.

The Plugin Site

http://thepluginsite.com

Plugin Commander Pro: Allows you to manage and pre-
view your plug-ins, convert to other plug-in formats,
and organize groups of plug-ins.

RESOURCES AND LINKS

Free Photoshop

http://www.freephotoshop.com/index.htm

Extremely large collection of downloads for both free and
commercial plug-ins.

geekbooks.com

http://www.geekbooks.com/photoshopplug-ins.html

Site for Daniel Gray Plug-in book published in 1997.

Grafo Maniac

http://hem.passagen.se/grafoman/plugtool/plugs.html

1,542 free filters to preview and download.

Photo Links

http://fraktali.849pm.com/photolinks1.html

Links to all type of software related to three-dimensional
and photo applications.

Photoshop Filters

http://www.photoshop-filters.com

Filter factory, downloads, Filter tools, plug-in links, and
discussion group.

Photoshop Plugins and Filters

http://fraktali.849pm.com/photoshop.html

Downloads for hundreds of plug-ins, brushes, actions,
and more.

Plugin Head

http://planeta.terra.com.br/informatica/pluginhead

Links to plug-ins, actions, Bryce, brushes, and add-ons.

Plugins.com

http://www.plugins.com/photoshop

Plug-in lists, tutorial, links, and Photoshop pages.

**Steve's Desktop Photography
(Formerly PC Resources for Photoshop)**

http://stevesdesktopphotography.com

The Plugin Site

http://thepluginsite.com

Vast resource for free and commercial plug-ins, filter fac-
tory, tutorials, discussions groups, galleries, links, plug-in
managers, and much more.

INDEX

Note: Plug-in manufacturers' names appear in bold type. Their products are set in italic.

Also by Jack and Sue Drafahl . . .

Digital Imaging for the Underwater Photographer

This book will teach readers how to improve their underwater images with digital imaging techniques. This book covers all the bases—from color balancing your monitor, to scanning, to output and storage. $39.95 list, 6x9, 224p, 80 color photos, order no. 1727.

Photo Salvage with Adobe® Photoshop®

This book teaches you to digitally restore faded images and poor exposures. Also covered are techniques for fixing color balance problems and processing errors, eliminating scratches, and much more. $29.95 list, 8½x11, 128p, 200 color photos, order no. 1751.

Step-by-Step Digital Photography

Avoiding the complexity and jargon of most manuals, this book will quickly get you started using your digital camera to create memorable photos. $14.95 list, 9x6, 112p, 185 color photos, index, order no. 1763.

Advanced Digital Camera Techniques

Maximize the quality and creativity of your digital-camera images with the techniques in this book. Packed with problem-solving tips and ideas for unique images. $29.95 list, 8½x11, 128p, 150 color photos, index, order no. 1758.

Big Bucks Selling Your Photography, *3rd Ed.*

Cliff Hollenbeck

Build a new business or revitalize an existing one with the comprehensive tips in this popular book. Includes twenty forms you can use for invoicing clients, collections, follow-ups, and more. $17.95 list, 8½x11, 144p, resources, business forms, order no. 1177.

The Best of Teen and Senior Portrait Photography

Bill Hurter

Learn how top professionals create stunning images that capture the personality of their teen and senior subjects. $29.95 list, 8½x11, 128p, 150 color photos, index, order no. 1766.

Portrait Photography

THE ART OF SEEING LIGHT

Don Blair with Peter Skinner

Learn to harness the best light both in studio and on location, and get the secrets behind the magical portraiture captured by this award-winning, seasoned pro. $29.95 list, 8½x11, 128p, 100 color photos, index, order no. 1783.

Power Marketing for Wedding and Portrait Photographers

Mitche Graf

Pull out all of the stops to set your business apart and create clients for life with this comprehensive guide to achieving your professional goals. $29.95 list, 8½x11, 128p, 100 color images, index, order no. 1788.

Beginner's Guide to Adobe® Photoshop® Elements®

Michelle Perkins

Take your photographs to the next level with easy lessons for using this powerful program to improve virtually every aspect of your images—from color balance, to creative effects, and much more. $29.95 list, 8½x11, 128p, 300 color images, index, order no. 1790.

The Best of Portrait Photography

Bill Hurter

View outstanding images from top professionals and learn how they create their masterful images. Includes techniques for classic and contemporary portraits. $29.95 list, 8½x11, 128p, 200 color photos, index, order no. 1760.

Beginner's Guide to Photographic Lighting

Don Marr

Create high-impact photographs of any subect with Marr's simple techniques. From edgy and dynamic to subdued and natural, this book will show you how to get the myriad effects you're after. $29.95 list, 8½x11, 128p, 100 color photos, index, order no. 1785.

Posing for Portrait Photography

A HEAD-TO-TOE GUIDE

Jeff Smith

Author Jeff Smith teaches sure-fire techniques for fine-tuning every aspect of the pose for the most flattering results. $29.95 list, 8½x11, 128p, 150 color photos, index, order no. 1786.

Professional Model Portfolios

A STEP-BY-STEP GUIDE FOR PHOTOGRAPHERS

Billy Pegram

Create portfolios that will get your clients noticed—and hired! Contains info on the modeling industry, photo techniques, and sample forms. $29.95 list, 8½x11, 128p, 100 color images, index, order no. 1789.

The Portrait Photographer's Guide to Posing

Bill Hurter

Get the posing tips and techniques that have propelled over fifty of the finest portrait photographers in the industry to the top. $29.95 list, 8½x11, 128p, 200 color photos, index, order no. 1779.

Master Lighting Guide for Portrait Photographers

Christopher Grey

Efficiently light executive and model portraits, high and low key images, and more. Master traditional lighting styles and use creative modi-fications that will maximize your results. $29.95 list, 8½x11, 128p, 300 color photos, index, order no. 1778.

Professional Digital Imaging

FOR WEDDING AND PORTRAIT PHOTOGRAPHERS

Patrick Rice

Build your business and enhance your creativity with the newest technologies, time-honored techniques, and practical strategies for making the digital transition work for you. $29.95 list, 8½x11, 128p, 150 color photos, index, order no. 1777.

permanent one in a commercial space. Jacobs outlines equipment needs, terminology, effective lighting setups and much more, showing you how to create top-notch portraits and still lifes. $29.95 list, 8½x11, 128p, 100 color photos index, order no. 1787.

Traditional Photographic Effects with Adobe® Photoshop®, *2nd Ed.*

Michelle Perkins and Paul Grant

Use Photoshop to enhance your photos with handcoloring, vignettes, soft focus, and much more. Every technique contains step-by-step instructions for easy learning. $29.95 list, 8½x11, 128p, 150 color images, order no. 1721.

The Best of Wedding Photography

Bill Hurter

Learn how the top wedding photographers in the industry transform special moments into lasting romantic treasures with the posing, lighting, album design, and customer service pointers found in this book. $29.95 list, 8½x11, 128p, 150 color photos, order no. 1747.